John Rocque's
DUBLIN

A GUIDE TO THE
GEORGIAN CITY

Colm Lennon and John Montague

Dublin City
Baile Átha Cliath

RIA
ROYAL IRISH ACADEMY

First published in 2010 by the Royal Irish Academy (www.ria.ie),
Irish Historic Towns Atlas, 19 Dawson Street, Dublin 2,
in association with
Dublin City Council (www.dublincity.ie), Wood Quay, Dublin 8.

Irish Historic Towns Atlas series editors: Anngret Simms, H.B. Clarke, Raymond Gillespie, Jacinta Prunty; consultant editor: J.H. Andrews; cartographic editor: Sarah Gearty; editorial assistants: Angela Murphy, Jennifer Moore.

British Library Cataloguing-in-Publication Data. A catalogue record is available from the British Library.

Printed in Ireland by Turner Print Group.
ISBN 978-1-904890-69-0.

CONTENTS

PART I INTRODUCTIONS

PART II MAP EXTRACTS AND COMMENTARIES

This book is one of a number of ancillary publications to the Irish Historic Towns Atlas. These are intended to make available material relevant to published atlas fascicles. This volume accompanies Irish Historic Towns Atlas, no. 19, *Dublin, part II, 1610 to 1756* (2008) by Colm Lennon. It explores one of the finest pieces of eighteenth-century Irish cartography, John Rocque's *Exact survey of the city and suburbs of Dublin* (1756), which is reproduced in full in the fascicle.

John Rocque's Dublin: a guide to the Georgian city is a joint publication between the Royal Irish Academy and Dublin City Council. The authors and editors are grateful to Edward McParland and Livia Hurley for reading drafts of the text; to Paul Ferguson, Map Librarian, Trinity College Dublin and Máire Kennedy, Dublin City Library and Archive for advice on the copies of the *Exact survey* in their collections; and to Charles Duggan, Heritage Officer for facilitating the grant from Dublin City Council.

Anngret Simms, H.B. Clarke, Raymond Gillespie, Jacinta Prunty
Editors, Irish Historic Towns Atlas, Royal Irish Academy

PREFACE

John Rocque's *Exact survey of the city and suburbs of Dublin* (1756) is a document whose importance has long been appreciated. In the history of Irish cartography it represents one of the finest achievements in mapping before the advent of the Ordnance Survey. This was a considerable triumph for one man and his team but Rocque's grounding in French and English cartographical techniques ensured that he was well prepared for it, as John Montague's introductory essay shows. For the history of Dublin the *Exact survey* is no less important since this detailed picture of the urban landscape was captured just at the end of the first stage of transforming the medieval city into something recognisably modern. It recorded the emergence of new patterns in the city's political, social, economic and cultural history by the middle of the eighteenth century. It mapped the new estates as Dublin spread outside its medieval walls; it revealed the topography of power as institutions such as Dublin Castle and the parliament building took on new roles; it charted the sacred geography of diverse confessional positions and it laid out the zones of economic activity that emerged in the eighteenth-century city. All this Colm Lennon outlines in his introduction.

Yet, when we look at Rocque's map we deal with a very different scale. It is difficult to absorb the topographical information at the level that Rocque presents it. By considering the *Exact survey* as a series of extracts rather than an overall sweep, this book is intended to help us to appreciate the achievement of Rocque and, through that, the texture of the eighteenth-century city at the level of individual streets and buildings. Exploiting Rocque's care in recording the city, this book asks the user to appreciate the *Exact survey* not as a whole but through the detailed extracts. By focusing on the representation of key buildings and quarters within the city, not only does the achievement of the cartographer become clearer but also the significance of those places in both topographical and cultural terms can be enhanced. The forty extracts from the *Exact survey* chosen here illustrate the cartographer's art and, by considering the micro-topography of eighteenth-century Dublin, reveal aspects of the city's history that have not been fully recognised. The commentaries by Colm Lennon and John Montague are intended to deepen our appreciation of both dimensions of the *Exact survey.*

 FOREWORD

The *Exact survey* consists of 4 sheets each 705 x 495 mm in size. The map was produced at the scale of 1 inch to 200 feet (1:2400). The map extracts included in this book have been taken from a set of sheets from the Map Library, Trinity College, Dublin, and they are reproduced with the permission of the Board of Trinity College. Changes to some details on the map show that this set of sheets represents a later altered state to the one first published. As the titles have not been changed, these are considered as later states of the original rather than a new edition, which was not published until 1773, by Robert Sayer in London, following the revised survey carried out by Rocque's brother-in-law, Bernard Scalé. Some alterations found on sheets 3 and 2 (see **27** and **14**) of the present map were carried out — as the topographical history of the city shows — as late as 1762 and 1769 respectively. This set of maps has been scanned, joined and cropped to provide the extracts. Each detail has been sized according to the area under discussion and the scale of enlargement or reduction for each is not given. The *Exact survey* gives true north correct to about half a degree west and the extracts follow the orientation of the original (see inside front cover for index map).

The map extracts are numbered **1** to **40**. Numbers in bold in the text provide a cross-reference to a relevant extract. The commentaries dealing with the title and scale cartouche have been placed first and last in the sequence of details. Otherwise, the order retains Rocque's own numbering of sheets 1 to 4 — clockwise from the Royal Barracks in the north-west to the Royal Hospital in the south-west and this can be followed on the index map inside the front cover.

In the introductory essays (part I), building and street names are standardised to those used in Irish Historic Towns Atlas, no. 19, *Dublin, part II, 1610–1756*. In the text that accompanies the map extracts (part II), the forms of name as given on the *Exact survey* are used.

EDITORIAL NOTE

Ancient records	*Calendar of ancient records of Dublin in the possession of the municipal corporation.* Ed. J.T. Gilbert and R.M. Gilbert. 19 vols. Dublin, 1889–1944.
BL	British Library, London.
BM	British Museum, London.
DHR	*Dublin Historical Record*. Dublin, 1938–.
NLI	National Library of Ireland, Dublin.
NUI	National University of Ireland.
RSAI Jn.	*Journal of the Royal Society of Antiquaries of Ireland*. Dublin, 1836–.
TCD	Trinity College, Dublin.
YCBA	Yale Center for British Art, New Haven.

 ABBREVIATIONS

LIST OF ILLUSTRATIONS

PART 1 ~ Introductions

JOHN ROCQUE AND THE *EXACT SURVEY OF DUBLIN*[1]

John Montague

John Rocque arrived in Dublin in 1754 amidst a flurry of self-generated publicity. In Faulkner's *Dublin Journal*, on 27 August, a notice, undoubtedly penned by Rocque himself, appeared: 'we hear the celebrated Mr Rocque (chorographer to his Royal Highness the Prince of Wales) who took the actual and accurate surveys of the cities and environs of London, Paris &c. is now employed … in making the same of this metropolis, in order to lay it down on the same scale'. Rocque proved as good as his word, by having an India-ink draft map of the city prepared by 26 October, the same year, and the engraved four-sheet plan of the city ready for sale on 13 November 1756, only two years later. For such an extraordinarily detailed map, this was a considerable achievement.

The map was a more impressive one than Rocque had first proposed. Unlike any of his previous city plans — the superb 24-sheet London map of 1747 being his most ambitious to date — his *Exact survey of the city and suburbs of Dublin* was a house-by-house survey. His other town maps were all confined to recording city block outlines and the plans of key public buildings. As stated in the title to the new Dublin map, Rocque's 1756 *Exact survey* contained 'the ground plot of all publick buildings, dwelling houses, ware houses, stables, courts, yards &c.'. This extent of detail was deemed exceptional even by the standards of Rocque, who stated with some justification that the map 'will exceed any yet published in Europe'.[2] The map Rocque first planned for Dublin was to have been of the block-by-block type he was already used to.[3] Indeed, Dublin had been surveyed in just such a manner some thirty years previously, by Charles Brooking.[4] It seems likely, however, that the competitive and ultimately over-ambitious

parallel plans to publish a Dublin map by the then Dublin city surveyor, Roger Kendrick,[5] spurred Rocque into proposing and finishing a much more detailed map than he had ever made before.[6] It is the extensive rigour and detail in Rocque's eventual map that has proved so useful to later Dublin historians and archaeologists.

WHO WAS JOHN ROCQUE?

Rocque was a Huguenot,[7] whose family were among the Reformed Protestants (Calvinists) who fled from France in the years following the revocation of the Edict of Nantes in 1685.[8] Apart from the time he spent in Dublin (1754–60) and one or two trips to Paris to purchase maps for resale, paper and other material, Rocque spent the greater part of his working career in London. Nearly all of his English town and county maps — Bristol (1743), Exeter (1744), Shrewsbury (1746), York (1750), the 16-sheet London and environs map (1746), the 24-sheet city map of London (1747), Buckinghamshire (1750), Shropshire (1752), Middlesex (1754), Berkshire (1761) and Surrey (1761) — were engraved after his own original surveys, as were his Irish maps. This cannot be said for his published plans of Lyons (1746), Paris (1748), Berlin (1749), Rome (1750), Nîmes (1751), Constantinople (1752) or Minorca (1753).[9] He may have visited some of the French cities named, but he certainly did not survey them. Instead, he artfully reworked earlier maps — a common practice, not unique to Rocque — in his own style. Rocque's Paris map, despite his claims in his first Irish advertisement quoted above, was based on an earlier survey by 'Mons.r Roussel, Cap.t Ingineer', as Rocque himself stated in the imprint to his own edition.[10]

 INTRODUCTIONS

Rocque's first publication, a map of the royal estate at Richmond, appeared in 1734.[11] In 1728 a Jean and Martha Rocque appeared as godparents to Jean Vivares, the son of the topographical engraver François Vivares, who was a close friend and business associate of the Rocques. This is the earliest certain record we have for him. Varley suggests a birth date of *c.* 1704–6 for Rocque, allowing for an apprenticeship from the age of fourteen and a seven-year period as a journeyman in advance of his first publication in 1734.[12] We know that other members of the family had spent time in Geneva, which was an important haven for refugee Huguenots, and it is possible that Rocque had come to London, from France, via Geneva.

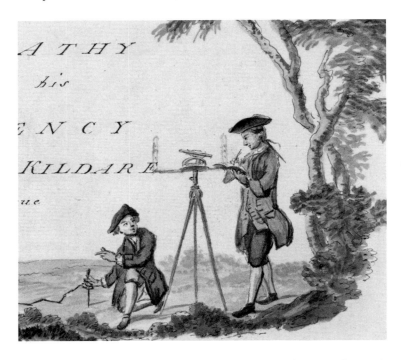

Fig. 1: A surveyor, possibly Rocque, and his assistant at work from one of Rocque's surveys of the earl of Kildare's estate (TCD, MS 4278).

ROCQUE'S PROFESSIONAL IDENTITY

In Rocque's Richmond map, he described himself is as a *dessinateur de[s] jardins*, suggesting to some that he had begun his career as a garden or landscape designer.[13] There is no evidence for such an interpretation. The word *dessinateur* can be translated either as designer or as draftsman but evidence suggests that Rocque's drawings and surveys recorded already existing gardens and country estates.[14] Rocque's brother, Bartholomew, who was based at Walham Green, Fulham, was a renowned horticultural innovator, who specialised in cultivating crops of exceptionally high yields.[15] There is no evidence that he ever was involved in estate design and management. Remarkably Bartholomew, like John Rocque himself, seems also to have been an engraver as well as a horticulturalist,[16] as was their nephew, Bartholomew, who was based at Mannheim.[17]

It seems plausible, given the length of time it takes to acquire such a skill, that Rocque was first trained as a topographical engraver, and only later emerged as a cartographer (Fig. 1, left).[18] As some have doubted whether Rocque engraved any of his own work,[19] it is important to re-assert his mastery of this art. Rocque established early his own authorial credentials when he stated that he 'measured, designed and engraved' his Wanstead plan.[20] He was responsible for many topographical publications with no cartographical element.[21] He was also involved as an engraver in a number of book publications: *Sixty different sorts of ornaments invented by Gaetano Brunetti Italian painter*, published in 1736;[22] as a cartouche engraver in Edward Hoppus's *The gentleman's and builder's repository*;[23] and with Hubert Gravelot, in Thomas Shaw's *Travels or observations relating to several parts of Barbary and the Levant*.[24] In other works, Rocque played a central role in the introduction of the French rococo style to England.[25] He was the publisher of a reworked, and arguably counterfeit, version of Meissonnier's *Livre d'ornemens*,[26] and the rococo cartouches on his estate maps of Chiswick and Hampton Court, both published in 1736, were the first of their kind to appear in that country.[27]

Although enlivened by a fertile and imaginative flavour of its own, Rocque's map style is French in origin. Strictly planimetric, city blocks are stippled, public buildings are diagonally hatched, and changes of level — hills and ground depressions — are depicted by hachures (a system of lines drawn close together) suggestive of the shaded sides of three-dimensional ground. The variety of Rocque's evocative symbols for landscape types and land use, and their various linear textures, lend a shimmering *chiaroscuro* to his maps, despite the occasional intensity of their detail.

INTRODUCTIONS

The most characteristically Rocquian engraving on many of his maps is arguably to be found in the cartouches, while much of the cartographical engraving was carried out by others.[28] The style of these rococo cartouches, such as those to be found on the Dublin map (see **1**, **40**) with their twisting vegetative elements, shows Rocque's assured mastery of difficult three-dimensional forms (Fig. 2, right). It was work that could not easily be farmed out to assistants, and their style remains remarkably consistent throughout his *œuvre* (Fig. 49). This kind of engraving skill is not acquired casually. It is more likely that it was his surveying and cartographical skills that Rocque picked up as his career developed, rather than the more hard-won skills of the decorative and topographical engraver.

How Rocque came to be chosen to survey what would become the most ambitious map of London in over eighty years, remains something of a mystery.[29] Nothing in his career before then suggested a capacity to undertake a cartographical survey on that scale. Indeed some of the difficulties he encountered confirm this view.[30] However, under the guidance of Peter Davall and Martin Folkes of the Royal Society, Rocque managed over a period of almost nine years to complete the extraordinary 24-sheet London map. Arguably more ambitious still are Rocque's county maps, begun hot on the heels of his London work. Original county surveying was notoriously perilous as a business venture,[31] and it is remarkable that Rocque remained solvent, though only barely, to the end of his career.[32]

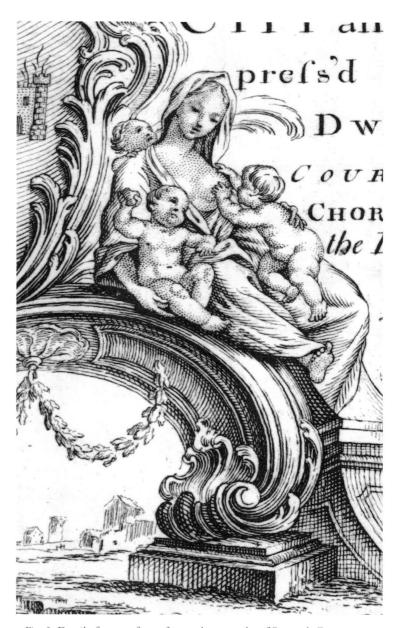

ROCQUE IN DUBLIN, 1754–60

All of this output — surveying, drafting, engraving and publishing — is likely to have put an enormous strain on one person.[33] In 1753, in a letter from London to his nephew Bartholomew in which he looked to convince him to move from Mannheim to England to take over his map-making operations, Rocque explained that he planned to quit his business as soon as the projects he had in hand were complete.[34] He claimed that he was no longer in a condition (*état*) to continue to produce as he had until then.[35] The nephew reneged, however. Despite his misgivings, Rocque continued to survey and publish county and city maps at the same astonishing rate for another nine years.[36] Indeed, only a year after he had written to Bartholomew, Rocque set about moving virtually his whole operation,[37] including a number of his assistants – J.J. Perret, Bernard Scalé and Andrew Dury – to Dublin,

Fig. 2: Detail of rococo frame from title cartouche of Rocque's *Exact survey*.

 INTRODUCTIONS

where he was to remain with only minor interruptions for the following six years.[38] In these years he was to bring into being a prodigious quantity of newly-surveyed original Irish maps.

Rocque's Irish works included the four-sheet *Exact survey of Dublin*, the often overlooked four-sheet *Survey of the city, harbour, bay and environs of Dublin* (1757), a four-sheet *Actual survey of the county of Dublin* (1760), and at least two compacted versions of the city plan: a *Parishes* map (1757) and a *Pocket plan* (1757).[39] Rocque also published a *Survey of the city of Kilkenny* (1758) and a *Survey of the city and suburbs of Cork* (1759), as well as a map of the County of Armagh (1760) in which important town plans of Armagh city and of Newry appear as insets. His *Map of the kingdom of Ireland* (n.d., *c*. 1760), was not based on original surveys, but on Henry Pratt's *Tabula Hiberniae novissima et emendatissima* of 1708.[40] Finally, Rocque produced the spectacular and beautiful eight-volume collection of watercolour survey maps of the estates of James Fitzgerald, earl of Kildare.[41] These introduced a wholly new approach to survey map production in Ireland and were of a quality not achieved by Rocque until then.[42] Collaborating with the younger Hugh Douglas Hamilton and Mathew Wren, Rocque created an approach to the drafting and production of topographical surveys whose influence was felt long after he returned to England.[43]

Rocque's commitment to his Irish concerns was demonstrated by the length of his stay in Dublin. He first took lodgings at the Golden Hart on Dame Street opposite Crane Lane.[44] This was an area with a high concentration of printers and booksellers.[45] When production of the map was fully under way, Rocque moved north of the river to 'Lower Ormond-key near the three Sugar Loaves, opposite the Bagnio Slip',[46] a site close to the present Halfpenny Bridge (Fig. 3, opposite page). Rocque also employed local artists and printmakers including George Byrne, Patrick Halpin and John Powell. His own compatriots included Scalé, Perret and Dury, already named, Samuel Andrews, a Huguenot colleague, and Gabriel Smith of unknown origins. No doubt many others, not credited, were also employed.

Work on the new map first involved a kind of macro-survey of the city. A baseline measurement was taken, from which long-distance angle readings were made from high vantage points in strategic locations. From these a triangulated substructure could be constructed on paper by trigonometrical means. Another more detailed street-by-street measurement, known as a street traverse, was also made. Its measurements were superimposed on the former draft and from this, a compromise, detailed map construct emerged.[47] A near-tragic start to the work was characteristically turned to good publicity. In early September 1754 it was reported that, while Rocque was 'measuring a base line for the survey of this city, and the environs, two of his men who were attending him with the chain on the sea coast between Irish Town and Roches Hill … got into a deep pool; and had it not been for the timely assistance of some people gathering stones, in all probability they had been drowned'.[48]

As early as May 1755 Rocque was in a position to announce that both the *Exact survey* and the *Harbour and environs* maps were 'now engraving', and that the drawings upon which these were based were on display at his lodgings.[49] It was not until June 1756, a year later, that substantial progress could be reported. 'Proofs of the four plates of the city and suburbs' were now on display at his shop on Ormond Quay. Its price to subscribers was to be £1 2s 9d, 'half now, and half on the delivery of the plan'.[50] In September Rocque was able to present the four sheets of his engraved map at the court of the lords justices, and could announce that it was 'allowed to be the best of that kind ever published'. The published sheets were finally available to the public from 13 November 1756.[51]

In contrast to the practical assistance given to him in London, from both the Royal Society and the London Corporation, Rocque was given little official support in Dublin, despite the enormous benefit that his mapping of the city would bring. Rocque received only £21 from Dublin Corporation.[52] In contrast, he generated more than £450 in subscriptions to the *Exact survey* on top of monies he earned from direct sales of his other maps. The Dublin Society generously subscribed to a full set of his published works, which John Putland, their treasurer, also seems to have done.[53] Many of the members of the Wide Streets Commission,[54] established by act of parliament in 1758,[55] were subscribers to the map, as were a very large number of titled gentry.[56]

Subscriptions were also received from other printmakers and members of related trades. The largest single order for the *Exact survey* came from the Paris map dealer, M. [Roch-Joseph] Julien, who subscribed to twenty-five sets. Copies were sold to colleagues such as Jonathan Baker (Barker), George Byrne, Thomas Cave, Patrick Halpin, George Semple (2 sets) and John Powell, and to members of Rocque's team and family, J.J. Perret, Bartholomew Rocque, Bernard Scalé and

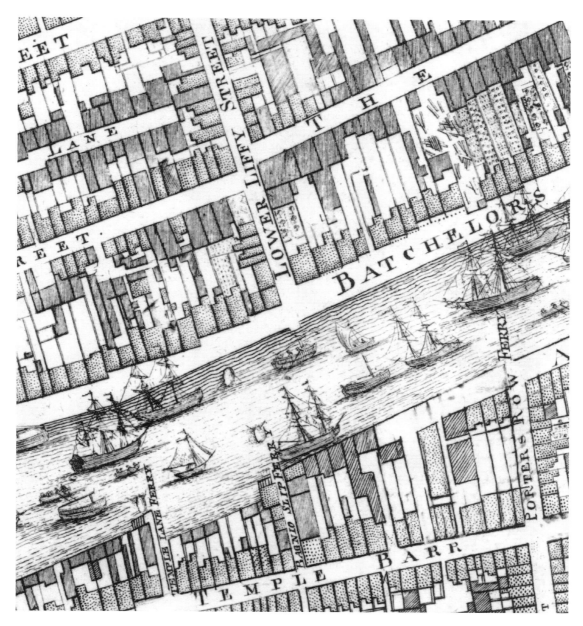

Fig. 3: The location of Rocque's premises on Lower Ormond Quay, 'opposite the Bagnio Slip', from the *Exact survey*.

 INTRODUCTIONS

Anne Scalé. Some local booksellers and printers also purchased copies: William Faulkner (12 sets), Thomas Merrill, Henry Saunders, William Sleater, Alexander Young (6 sets), and George and Alexander Ewing (8 sets). The Library of Geneva and the Republic of Geneva also received sets, as did King George II, who was presented with the map. In a 'Letter from London', dated 23 December 1756, it was announced with great pride that 'the expressiveness of this plan gave so high a satisfaction to his Majesty, that he ordered it to be hung in his own apartment'.[57]

ROCQUE'S *EXACT SURVEY* CONSIDERED

The commentaries that make up this book point to the rich quality and extent of Rocque's map of mid-eighteenth-century Dublin. So much can be recovered from his map that has otherwise disappeared from the archival record, or could be interpreted only with much greater difficulty from textual documents that have survived. This is partly due to the nature of visual evidence and partly the effect of Rocque's relentless thoroughness. There is an ingenuous lack of agenda in what he recorded so that, as we shall see in the commentaries that follow, houses and back-lane industrial buildings are depicted with as much or as little care as some of the most important mansions and public buildings.

In fact, Rocque's plans of individual large buildings are the most disappointing. We shall see that his image of the Parliament House (later Bank of Ireland) (see **18**) displays some key errors, while his plan of Christ Church Cathedral (see **28**) is hopelessly misconceived. Perhaps because of his own possible attendance at the French church located in the Lady Chapel there, his record of St Patrick's Cathedral (see **30**), in contrast, is much more careful and accurate. In at least one instance, Rocque left us with an important visual record of a designed garden, once belonging to Jonathan Swift (see **31**). However, by and large, the locked interiors of city blocks and the rear plots and returns of houses were rendered with much less faithfulness than those areas accessible from the street. In his defence, this was to be expected from a survey that had no official support and therefore no right of access to private areas. It is also the case, as demonstrated by Bill Frazer, that Rocque took certain shortcuts in some of the more obscure or poorer areas of the city, where the number of houses and their respective frontages were often guessed at rather than reliably recorded.[58]

Otherwise, as a visual census of the city and a representation of the grain, texture and relative densities of development across the capital, Rocque's map serves extremely well. His record of the negative space of streets and squares is highly reliable and can usually be backed up by comparisons with the later Ordnance Survey maps and by surviving archaeology. The underlying substructure, the orientation of the major streets and how the city fitted together as a whole hold up best of all. This has been tested against the first edition of the Ordnance Survey map of Dublin, using the recently-developed computer application MapAnalyst.[59] Here the nature and extent of overall error, as expressed graphically by a distortion grid, is surprisingly small. Other favourable comparisons may be made with Scalé's revision of Rocque's original in 1773, in which only minor editorial corrections were made in contrast to the changes to the map reflecting developments and alterations to the fabric of the city.[60]

What marks out Rocque's *Exact survey of Dublin* most of all is its house-by-house approach. Rocque used a system of graphic symbols to indicate different types of building, distinguishing dwelling houses from service and industrial buildings. Public buildings and churches were also demarcated graphically, as were places of worship of the non-Established church including Roman Catholic chapels.[61] The extent of detail means that Rocque's *Exact survey* will continue as a source of further discoveries. While Rocque was sometimes slapdash in his approach — usually in order to finish what was an incredibly ambitious project funded solely on a commercial basis — his map remains an invaluable visual treasure and a record of unique importance for any reconstruction of the early modern city.

INTRODUCTIONS

DUBLIN IN 1756

Colm Lennon

When the municipal authorities of Dublin in 1757 acknowledged the services of John Rocque, who had surveyed their city in 1756, they were in a position to celebrate over a century of rapid urban growth. The *Exact survey* showed hundreds of new streets and lanes that were named for the first time, attesting to the development of extensive urban estates to the north and south of the River Liffey. Well over 10,000 houses and other premises, including many major public buildings, were delineated in the cityscape. Substantial additions to the infrastructure of the city and its environs, including the port, reflected the expansion of commerce, and more intensive industrial and trading activity was suggested by new market places.[62] With this representation by Rocque, Dublin took its place among the great metropolitan centres of Europe, including London, which he had already mapped.

One measure of the new-found importance of Dublin as a capital city and centre of governance was the presence in 1756 of some impressive administrative buildings that had been recently constructed or refurbished. The Tholsel (see **29**), where the city council and guild merchant had their headquarters, had been rebuilt in the 1670s on its existing site in the heart of the old intramural area opposite Christ Church Cathedral. With its cupola and statuary, it bodied forth the power of the municipality.[63] To the east, in the new urban hub, Dublin Castle (see **27**) had been almost completely reconstructed after the disastrous fire of 1684. It now projected a majestic image as the centre of vice-regal government and pageantry.[64] Farther east, at the other end of Dame Street, stood the magnificent new parliament building

(see **18**), a suitably stately venue for the bicameral assembly of the kingdom of Ireland (Fig. 4, next page).[65] All three administrative sites were joined by the Skinner Row (Christchurch Place)/Castle Street/Dame Street artery, with the relative power of the state suggested perhaps by the centrality of the castle. Meanwhile, the lord mayors of Dublin had established their residence at the Mansion House in the newly laid out Dawson/Molesworth suburb (see **21**).

The municipality of Dublin over which the lord mayors presided was the largest landlord within the urban environs, and it had sponsored a programme of development of city lands from the late seventeenth century. The results could be seen in 1756 in the harmonious plan of St Stephen's Green (see **22**, **24**), Dublin's first residential square, which had substantial dwellings on all sides, fronting a landscaped park that provided a pleasure ground for the city's leisured classes.[66] Not quite so coherent was another civic scheme on the north side of the Liffey in Oxmantown, where a mix of gentry and mercantile dwellings similarly faced on to an urban space, this one designated as Smithfield Market (see **4**).[67] The precedent of the drawing of lots by builders for sites in these developments was also applied to the sloblands at the entrance to the port area of the city, the process giving its name to the North and South Lotts. The plots so designated were to be reclaimed and built up as quays and streets in and near the riverfront, though the North Lotts lagged behind its southern counterpart in terms of urbanisation.[68]

Parallel to these municipal schemes for the developing and reclaiming of urban lands were the plans of private landlords for the

INTRODUCTIONS

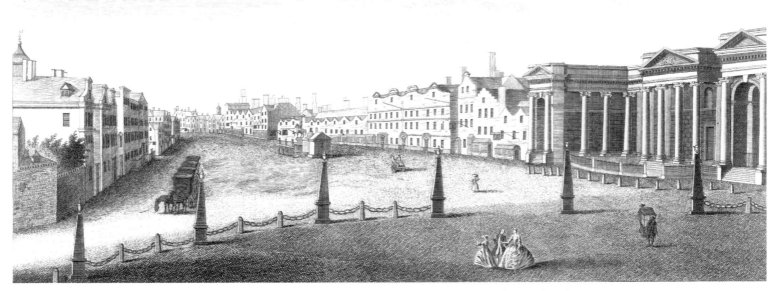

Fig. 4: Parliament House, College Green and Dame Street, 1753, by Joseph Tudor.

laying out of urban estates mainly on former monastic properties. The Aungier suburb (see **25**) of the earls of Longford was the first to shape a suburb out of abbey lands, in this case those of the Whitefriars to the south of Dublin Castle. Within the old monastic enclave, the outlines of which were still traceable in the streetscape of 1756, there emerged a grid plan of streets and lanes, sites being acquired by individual developers and speculators for substantial houses. The Aungier suburb was aligned with the network of streets leading off St Stephen's Green in an early instance of inter-neighbourhood planning.[69] On the north side of the city, the estate of St Mary's Abbey (see **9**) was acquired by Sir Humphrey Jervis who laid out his grid-planned suburb within its contours. New streets such as Capel, Mary and Abbey Streets gave shape to the district that was eventually taken on by the Moore family and developed eastwards to Drogheda Street, later Sackville Mall (O'Connell Street) (see **14**). Under the succeeding landowning family, the Gardiners, the quarter reached its zenith of urban refinement in the spacious streets and mall, the elegant housing and the residential squares.[70] The fashionability of the north-eastern city quadrant came

to be matched by that of the south-eastern, which was developed, mostly after 1756, by the Fitzwilliam family. The appointing by the duke of Leinster of his town house in the heart of the quarter helped to attract many other upper-class residents to it, as he had predicted.[71]

With the emergence of these new urban estates by 1756, there was a demand for infrastructural improvements to support the expanding population and fabric. The quaying of the Liffey had taken place in tandem with the developments on the north and south banks, and the laying out of wide passages on either side of the river improved traffic circulation.[72] A series of bridges came into being to facilitate movement to and fro between the new suburban districts. The earliest, Bloody Bridge (later Rory O'More Bridge), had been erected to the west of the built-up area in 1670, and there followed in quick succession the building of Arran or Bridewell, Ormond and Essex Bridges (later Mellowes, O'Donovan Rossa and Grattan Bridges). These new structures helped to shift the urban centre of gravity away from the old city bridge, linking the mural enclave and Church Street, and instead forged a new hub around Essex Bridge (see **11**), which had been re-

INTRODUCTIONS

cently rebuilt when Rocque surveyed Dublin.[73] Radiating out from this pivotal point were the quays on which stood such significant buildings as the Custom House, and streets such as Capel Street, connecting the Jervis suburb with the heart of Dublin at the castle. To cater for the increased number of houses, a more voluminous water supply was needed, a large new City Basin (see **36**) being erected at James's Gate and new pipes being installed along the conduit to the city through James's Street and Thomas Street.[74] The major engineering feat in the age of Rocque, which appeared on his *Survey of the city, harbour, bay and environs of Dublin* (1757), was the construction of the south wall within the bay of Dublin by the newly-established ballast office, for the purpose of deepening the channels of the Liffey estuary and improving the safety of the port for shipping.[75]

Participation by the state in the aggrandisement of Dublin was not limited to the funding of the central sites of administration such as the castle and parliament, or the financing of large infrastructural projects undertaken by the ballast office. The government also sponsored institutional building in the spheres of health, security and education. An early example of this was the erection in the early 1680s of the Royal Hospital (see **39**) at Kilmainham for the care of superannuated soldiers. Chosen partly because of its healthful location at some distance from the city centre, the site came to be occupied by a magnificent edifice that bore the signs of generous patronage.[76] Two decades later, also on the westerly outskirts, the Royal Barracks (later Collins Barracks) (see **2**) was constructed on a riverside site. This, the first such free-standing barracks in the islands of Britain and Ireland, solved the long-running problem of troops being billeted in city households and established the military headquarters outside of the central urban area.[77] Another prestigious project for which government monies were made available was the embellishment of Trinity College (see **19**), with features such as the west front facing on to College Green and the library and printing house.[78]

Rocque's Dublin also depicted the many new civic institutions established within the previous decades for the alleviation of poverty and the treatment of illness. To counteract the threat from importunate begging in the streets, a municipal bridewell had been built in Oxmantown to house those deemed fit enough but unwilling to work. This was reconstructed as the City Workhouse (see **37**) in the 1720s on a new site south of the Liffey, and within the same complex of

buildings was erected a bedlam for the containment of the mentally ill and a foundling hospital. Close to the original bridewell in Oxmantown was raised the King's Hospital (or Blue Coat Boys Hospital) (see **3**), for the education and care of impoverished youths. By 1756 a series of purpose-built hospitals had been constructed in the western outskirts, including Dr Steevens's and St Patrick's, as well as the soldiers' infirmary (see **38**). Dr Bartholomew Mosse, who had opened a maternity hospital in George's Lane (South Great George's Street) in the 1730s, developed a plan for a grander institution at the top of Sackville Street in the fashionable suburb to the north-east of the city. This building, later known as the Rotunda (see **13**), had adjacent gardens and entertainment facilities to be used for the raising of funds at charity events for the support of the hospital.[79]

The growth of trade within the city was marked by the appointing of new facilities and spaces for the marketing of goods. In a move to foster better hygiene and ease traffic congestion, the old fish, flesh and vegetable markets were removed from the cramped old intramural area and moved to purpose-built facilities across the river at Smithfield and the Ormond Market (see **8**).[80] New trade and guild halls to cater for traders and manufacturers of cloth and other commodities were constructed, including the Linen Hall (see **6**) to the north and the Weavers' Hall to the south of the city.[81] An extensive new market campus was designated in the heart of the suburb that had come into being in the earl of Meath's old liberty area of St Thomas and Donore (see **32**). Here was centred the textile manufacturing industry of early modern Dublin, in areas such as the Coombe and Weavers' Square. Also evident on Rocque's map of this artisanal suburb were the tenterfields that facilitated the drying of cloth hooked to frames (see **33**). Industrial development in this area was encouraged by the planned immigration of continental cloth workers in areas such as silk weaving, many of them Protestant refugees.[82]

These newcomers added to the mixture of denominational groups that made up the population of mid-eighteenth century Dublin. This multiplicity was reflected in the many types of church, chapel and meeting house that were shown by Rocque, who was himself of French Huguenot background. Worship in that confession was carried on in a number of locations throughout the city, including the Lady Chapel of St Patrick's Cathedral (see **30**). The Quakers had established a number of meeting houses, one of the most significant being in the Temple Bar

 INTRODUCTIONS

area. Methodists, Lutherans and Moravians also added to the complement of Protestant groups, many of whom met in a cluster of streets and lanes to the south of Dublin Castle and east of St Patrick's Cathedral (see 26).[83] Roman Catholic mass houses had become more substantial, evolving into chapels by the early eighteenth century, a total of twenty diocesan and religious places of worship (including some convents) being scattered throughout the city. The area between Cook Street to the south and the river to the north contained a number of these chapels (see 34), still adhering to their traditional pre-Reformation parochial boundaries. Most of these non-established religious premises were unpretentious and located off the main thoroughfares.[84]

By contrast, the early eighteenth century witnessed an upsurge in the building of Anglican parish churches in prominent locations. In fact, these new places of worship gave a focus to the urban estates that came into being in the decades after the 1660s. For example, the Jervis suburb in the old St Mary's Abbey lands acquired a new parish church with that same dedication in the early 1700s (see 10). St Ann's Church became the parochial centre for the Dawson/Molesworth development (see 21), St Luke's came to serve the earl of Meath's south-western suburb (see 32), St Paul's catered for Oxmantown and Smithfield (see

3), and St Mark's was raised in the Townsend Street district. There was some rebuilding of old churches on or near the previous locations, such as St Peter's in the Aungier quarter (see 25), St James's along the eponymous street and St Andrew's (see 20), an innovatively designed church close to Trinity College, replacing an older structure near Dublin Castle. The two cathedrals, Christ Church (see 28) and St Patrick's (see 30), as well as the older parish churches of the Church of Ireland — St Audoen's, St Werburgh's (see 28) and St Michan's — underwent sporadic rebuilding and restoration work.[85]

Rocque's map of Dublin captured the emergent culture of leisure in its delineation of spaces dedicated to recreation and sociability (Fig. 5, below). The Phoenix Park fringed the west of the city, and other places where citizens disported themselves included the City Basin (see 36), which had a tree-lined promenade popular with strollers, as well as St Stephen's Green (see 22) and Gardiner's Mall (see 14), which were for more elitist display. The bowling greens at Marlborough Street (see 15), Dawson Street (see 21) and Oxmantown (see 3) were used for sporting activity and general sociability, the Rotunda gardens (see 13) were a venue for charitable benefits, and indoor spaces such as the Fishamble Street and Crow Street music halls

Fig. 5: View of the city from Phoenix Park, 1753, by Joseph Tudor.

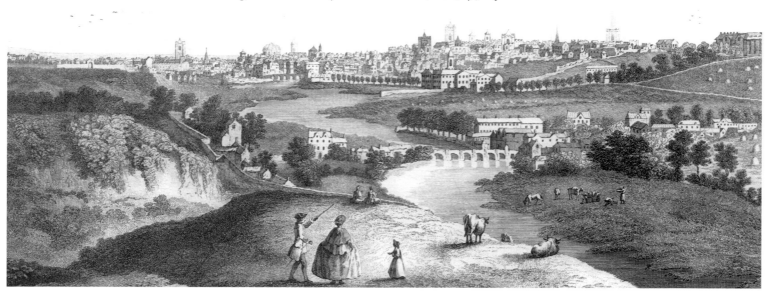

also staged concerts to raise funds for civic and private charities.[86] Not apparent on Rocque's map were the coffee houses and printing shops that provided places for social and political discourse as well as reading.[87] While sales of the *Exact survey* may have been slow initially, the city fathers could express satisfaction in 1757 that Rocque had, 'with great pains, labour and expense', produced a work that was 'agreeable to his great plan of the city of London', always for them a benchmark of cosmopolitan accomplishment.[88]

Rocque's *Exact survey* of Dublin illustrates the major themes in the city's political, social, economic and cultural history in the mid-eighteenth century. Important landmark buildings or sites that reflect the power of the state and municipality include the Royal Barracks, Dublin Castle, Parliament House, Trinity College and the Tholsel. Projects in civic planning such as St Stephen's Green and Oxmantown Green complement those undertaken by the private developers, Aungier, Jervis, Dawson, Molesworth and Brabazon, earl of Meath. Charitable ventures initiated by public and private patrons are represented by the Royal Hospital, the City Workhouse, the King's Hospital, Dr Steevens's, St Patrick's and the lying-in hospitals. Urban economic and commercial enterprise was facilitated by advances in infrastructure and utilities, symbolised here by the Essex Quay hub, the Linen Hall and tenterfields as foci of manufacture, the City Basin and Thomas Street water supply, and the industrialised North Lotts. Sites of cultural diversity in the city, incorporating places of worship among Protestant denominations and the Roman Catholic community, counterpoint those of Anglican religious uniformity such as the two cathedrals and two new churches, St Mary's and St Luke's. The new culture of leisure is depicted attractively in the landscape of the gardens of the Rotunda and Jonathan Swift's 'Naboth's Vineyard', the green spaces of the Marlborough Bowling Green and the basin, and the urban mall of Sackville Street. Rocque's own professional and artistic interests may be discerned in his lyrical cartouches (see **1**, **40**) and the careful detail devoted to the houses of his patrons and associates, Putland and Landré (see **23**).

It is to be hoped that a balanced picture is presented here from Rocque's map of the old and the new, the majestic and the quotidian, and the artistic and the utilitarian, reflecting the emergence of a multifaceted metropolis of Dublin by the later eighteenth century.

 INTRODUCTIONS

[1] The material outlined in this introduction is based on this author's Ph.D. thesis, John Montague, 'John Rocque and the making of the 1756 *Exact survey of Dublin*' (TCD, 2009) and will be further elucidated in a planned monograph publication based on this work. Two important published sources for the study of Rocque's *Exact survey* are J.H. Andrews, 'Two maps of Dublin and its surroundings by John Rocque', in *An exact survey of the city and suburbs of Dublin 1756 by John Rocque* (Lympne Castle, 1977); and Paul Ferguson (ed.), *The A to Z of Georgian Dublin* (Lympne Castle, 1998), which also reproduces the earlier Andrews article.

[2] *Dublin Journal*, 13 May 1755.

[3] In Rocque's earliest announcements, his proposed maps were to be at the same scale and with the same detail as those he had done before then: e.g. *Dublin Journal*, 27 Aug. 1754. In the 10 Sept. issue of the *Dublin Journal* Rocque states that he plans that a 'true ground plot of all public buildings, streets, lanes, courts, alleys, &c. will be therein expressed with the boundary of the city and the other Liberties contiguous'. There is no mention at this stage of the 'dwelling houses, ware houses, stables … [and] yards' that were to appear on the *Exact survey*. The same reduced level of detail is referred to in Rocque's broadsheet proposal published on 5 Sept. 1754 (a copy in TCD, OO.a.59. no. 1B).

[4] Charles Brooking, *A map of the city and suburbs of Dublin. And also the archbishop and earl of Meaths liberties with the bounds of each parish, drawn from an actual survey* (London, 1728); see also J.H. Andrews, '"Mean pyratical practices": the case of Charles Brooking', in *Quarterly Bulletin of the Irish Georgian Society*, xxiii (1980), pp 33–41.

[5] *Dublin Journal*, 3 Aug. 1754, 31 Aug. 1754, 10 Sept. 1754, 2 Nov. 1754.

[6] While Rocque's Dublin map captures more architectural detail than his earlier London map, both were surveyed at approximately the same scale: 1 inch to 200 feet (1:2400) for the Dublin map and 1 inch to 220 feet (1:2640) for the London map.

[7] Much of what can be gleaned of Rocque's personal history is first assembled in John Varley, 'John Rocque. Engraver, surveyor, cartographer and map-seller', in *Imago Mundi*, v (1948), pp 83–91. See also Henry Wheatley, 'Rocque's plan of London, 1746', in *London Topographical Record*, ix (1914), pp 15–28; Hugh Phillips, 'John Rocque's career', in *London Topographical Record*, xx (1952), pp 9–25; Paul Laxton, 'Rocque, John (1704?–1762)', in *Oxford Dictionary of National Biography*, ed. H.C.G. Matthew and B.H. Harrison (61 vols, Oxford, 2004) and www.oxforddnb.com (last accessed 30 June 2010).

[8] J.-P. Pittion, 'The French Protestants and the edict of Nantes (1549–1685): a chronology based on material in Marsh's Library, Dublin', in C.E.J. Caldicott, H. Gough, and J.-P. Pittion (eds), *The Huguenots and Ireland: anatomy of an emigration* (Dún Laoghaire, 1987), pp 37–66.

[9] The most comprehensive list of John Rocque's publications can be found at Ashley Baynton-Williams, 'John Rocque: catalogue of his engraved works', in *MapForum.Com, specialist antique map magazine*, www.mapforum.com/05/rocqlist.htm and www.mapforum.com/05/rocqlis2.htm (last accessed 30 June 2010).

[10] *Plan of Paris and the adjacent country … levé par Mon.r Roussel Cap.ne Ingenieur du Roy* ([London], 1748).

[11] *Plan of the house, gardens, park, & hermitage of their Majesties, at Richmond; and of their R.H. The Prince Of Wales, & The Princess Royal at Kew* (London, 1734).

[12] Varley, 'John Rocque', p. 84.

[13] Renzo Dubbini, *Geography of the gaze*, trans. L.G. Cochrane (Chicago and London, 2002), pp 42–3; hinted at by Varley, 'John Rocque', pp 83–4.

[14] A fuller discussion of this point and much else to do with Rocque's professional identity and practices appears in Montague, 'Exact survey of Dublin', chapter 2.

[15] Sir James Caldwell referred to Bartholomew as 'this great artist in agriculture', in 'A letter to the Dublin Society, from Sir James Caldwell, Baronet, Fellow of the Royal Society; giving an account of the culture and quality of several kinds of grass lately discovered. volume v', in *Museum rusticum et commerciale* (London, 1765), pp 13–22.

[16] The engraver of three of John Rocque's publications is listed as B. Rocque. These include an estate plan of the *Garden & house of the Rt. Honourable ye. Earl of Lincoln at Weybridge in … Surrey* (1737); a plan of *Drumlangrig in Scotland, the seat of his Grace ye. Duke of Queensburry* (1740); as well as two plates in John Rocque's 1737 reworking of Meissonnier's *Livre d'ornemens* (see below, n. 26), otherwise engraved for Rocque by his friend François Vivares.

[17] Friedrich Walter, 'Zur Lebensgeschichte des Kupferstechers: B. Rocque (de la Rocque)', in *Mannheimer Geschichtsblätter*, xxi, no. 7/8 (1920), pp 99–105.

[18] For a consideration of Rocque's work in the context of contemporary topographical art, see John Harris, *The artist and the country house: a history of country house and garden view painting in Britain 1540–1870* (London, 1979), pp 154–5, 171, 185.

[19] Paul Laxton (ed.), *A topographical map of the county of Berks, by John Rocque, topographer to his majesty* (Lympne Castle, 1973).

[20] 'Levé dessienné / et grave par J. Rocque. 1735.'

[21] These include *View of the Royal Palace at Kensington*, engraved by Vivares, copy in BL, Maps K.Top.28.10.e.2; *View of Geneva* described in Ralph Hyde, 'Portraying London mid-century: John Rocque and the Brothers Buck', in Sheila O'Connell (ed.), *London 1753* (London, 2003), pp 28–38; *A new book of landskips pleasant & useful for to learn to draw without a master* (London, 1737), copies in BM 1882,0411.1330–1334 and YCBA, Prints and Drawings, cabinet 93, shelf 10; Thomas Badeslade and John Rocque, *Vitruvius Brittanicus, volume the fourth* (London, 1739).

[22] Gaetano Brunetti, Henry Fletcher and John Rocque, *Sixty different sorts of ornaments invented by Gaetano Brunetti Italian painter* ([London], 1736); see also Christine Casey, 'Gaetano Brunetti', in *The GPA Irish Arts Review Yearbook* (1988), pp 244–5.

[23] *The gentleman's and builder's repository, or, architecture display'd: containing the most useful and requisite problems in geometry … drawn by E. Hoppus, engraved by B. Cole* (London, 1737).

[24] Oxford, printed at the Theatre, 1738.

NOTES

25 Michael Snodin and Elspeth Moncrieff (eds), *Rococo: art and design in Hogarth's England* (London, 1984), p. 35.

26 *A book of ornaments invented & drawed by J.O. Meissonnier* (1737), published by John Rocque, plates engraved by Bartholomew Rocque and François Vivares.

27 *Plan du Jardin & Vuë des Maisons de Chiswick, sur da Tamise …* (London, 1736); *… This plan of y.e Royal Palace and gardens of Hampton Court …* (London, 1736).

28 The principal engraver on the *Exact survey* was Rocque's Huguenot colleague, Andrew Dury.

29 The idea for the map may be attributed to George Vertue, the antiquarian printmaker, who first approached Rocque in 1738 as a prospective surveyor for the map: Hyde, 'John Rocque's map', p. v.

30 John Rocque and John Pine, *An alphabetical index of the streets, squares, lanes, alleys … in the plan of the cities of London and Westminster and borough of Southwark* (London, 1747), p. vi.

31 J.B. Harley, 'The re-mapping of England, 1750–1800', in *Imago Mundi*, xix (1965), pp 56–67. See also below, n. 33.

32 Phillips, 'Rocque's career', p. 9.

33 For more on the consequences of a contemporary map-maker's over-extending himself, see J.B. Harley, 'The bankruptcy of Thomas Jefferys: an episode in the economic history of eighteenth century map-making', in *Imago Mundi*, xx (1966), pp 27–48.

34 '[J]e me propose avec laide de Dieu, de quitter tout commerce lorsque les entreprisens que j'ai en main seron finies ce qui me tiendra en corre quelque Années', letter from John Rocque to Bartholomew Rocque in Mannheim, 11 May 1753: Mannheim, Gesellschaft der Freunde Mannheims und der ehemaligen Kurpfalz, MS.

35 Ibid., 'je ne suis plus en État de faire ce que j'ai fait'.

36 Rocque died in 1762: Varley, 'John Rocque', p. 83.

37 It is likely that his wife, Mary Anne, remained in London, where she probably managed Rocque's business concerns there. She is not mentioned in any of the published or other records of Rocque in Dublin. For a number of years after his death, Mary Anne Rocque continued publishing Rocque's maps, using both her own and his names on the imprints.

38 There was at least one likely return trip to London, in 1759, when Rocque made an application for funding for proposed maps of Berkshire, Oxfordshire and Buckinghamshire to the Royal Society of Arts (Royal Society of Arts, London, PR.AR/103/10/146). Rocque did not finally leave Dublin until August 1760: *Dublin Journal*, 19 Aug. 1760.

39 For a full list of Rocque's Dublin maps, see Andrew Bonar Law and Charlotte Bonar Law, *A contribution towards a catalogue of the prints and maps of Dublin city and county* (2 vols, Shankill, 2005), ii, pp 344–60.

40 J.H. Andrews, *Shapes of Ireland: maps and their makers 1564–1839* (Dublin, 1997), p. 179.

41 These manuscript map volumes, listed here in approximate order of their production, are spread across a number of repositories and private collections: Woodstock, 1755–7 (BL); Athy, 1756 (TCD); Maynooth, 1757 (Cambridge, University Library); Kildare, 1757 (TCD); Castledermot, 1758 (NLI); Graney, 1758 (YCBA); Rathangan, 1760 (private collection, whereabouts unknown); Kilkea, 1760 (private collection, recently sold by Robin Halwas Ltd). For the latter, see Robin Halwas, *John Rocque's survey of the Kildare estates: manor of Kilkea, 1760* (London, [2005]).

42 The far less impressive manuscript surveys known to have been carried out by Rocque before he came to Ireland include the following: 'A Survey of Wrington Tything, belonging to the Rt. Hon. Wm. Pulteney, Esq … 1738' (Bristol Records Office, 22160, 1–3). See *Wrington village records*, compiled by members of a University of Bristol extra-mural class held at the John Locke Hall, Wrington (Bristol, 1969), p. 44; a survey of 'a farm at Parsfield Hall, High Ongar in Essex for Earl Tylney' (Essex Record Office, D/DCW, P46), referenced in A.S. Mason, *Essex on the map: the 18th century land surveyors of Essex* (Chelmsford, 1990), p. 71; and a survey of land at 'Walton on Thames, in Surrey' in A.S. Mason, 'Some Huguenot surveyors and the Irish connection: abridged version', lecture typescript (1989), p. 6.

43 J.H. Andrews, 'The French school of Dublin land surveyors', in *Irish Geography*, xlv (1964–8), pp 275–92; Anne Hodge, 'The practical and the decorative: the Kildare estate maps of John Rocque', in *Irish Arts Review*, xvii (2001), pp 133–40.

44 *Dublin Journal*, 13 May 1755.

45 E. MacDowel Cosgrave, 'On two maps, dated 1751 and 1753, of the Essex Bridge district, Dublin', in *RSAI Jn.*, xlviii (1918), pp 140–49; Mary Pollard, *A dictionary of members of the Dublin book trade 1550–1800* (London, 2000), pp 198, 443 and *passim*.

46 *Dublin Journal*, 29 July 1755.

47 This approach was developed for the production of the London map, under the guidance of Peter Davall, who published a number of articles on the process that were inspired in turn by the published work of the French cartographer, Guillaume Delisle: Peter Davall, 'Some reflections on Mr De Lisle's comparison of the magnitude of Paris with London and several other cities … ', in *Philosophical Transactions*, xxxv (1727–8), pp 432–6; Guillaume Delisle, 'Détermination géographique de la situation et de l'étendue des différentes parties de la Terre', in *Mémoires des sciences* (27 Nov. 1720), pp 356–84; M[r Guillaume] Delísle l'Aîné, 'Examen et comparaison de la grandeur de Paris, de Londres, et de quelques autres villes du monde, anciennes et modernes', in *Mémoires de l'académie royale des sciences* (1725), pp 48–57. This combined approach of triangulation and street traverse measurements is elucidated more fully in Montague, 'Exact survey of Dublin', chapter 3.

48 *Dublin Journal*, 10 Sept. 1754.

49 *Dublin Journal*, 13 May 1755.

50 *Dublin Journal*, 26 June 1756. The map, however, had been available to subscribers earlier at the slightly cheaper price of one guinea (21 shillings), and a guinea and a half to non-subscribers: *Dublin Journal*, 22 Nov. 1755.

 NOTES

51 *Dublin Journal*, 13 Nov. 1756.

52 *Dublin Journal*, 29 Jan. 1757; *Ancient records*, x, p. 252: 'John Rocque, topographer to HRH the Prince of Wales, praying to be considered for taking & publishing an exact survey of this city & its environs (agreeable to his great plan of … London) in 4 sheets, which [with] great pains, labour & expense, he reduced into one sheet, & that the subscriptions for the work have not in any sort answered his expectation. To be paid 20 guineas'.

53 Royal Dublin Society, minute book, 27 Jan. 1757: 'Mr. La Rocque delivered to the Society a List of his several Maps. Ordered that they be purchased for the use of the Society and that the Treasurer do pay him sixteen pounds thirteen shillings and six pence in full for them'. For a record of Putland's purchase see manuscript inscription on the verso of the TCD copy of Rocque's 5 Sept. 1754 broadsheet proposal for the *Exact survey* (see above, n. 3).

54 William Brownlow, Sir Arthur Gore, Rt Hon. Arthur Hill (later Lord Dungannon), James Hamilton Esq., the earl of Kildare (5 sets), Viscount Lanesborough, Aland Mason, John Ponsonby (speaker of the House of Commons, 1756–70), Henry Sandford and Philip Tisdall.

55 31 Geo. II, *c.* 19.

56 The subscribers' list appeared as a separate folio broadsheet, with a two-coloured title page to the *Exact survey* on the recto, and subscribers' list on the verso. Different states of this printed list survive: e.g. TCD, OO.a.58; King's Inns Library, Dublin, in 'Rocque's maps of Dublin'; Gilbert Library, bound maps; and a copy in Armagh Public Library.

57 *Dublin Journal*, 1 Jan. 1757.

58 Bill Frazer, 'Cracking Rocque?', in *Archaeology Ireland*, xviii (2004), pp 10–14.

59 Bernhard Jenny, 'MapAnalyst — a digital tool for the analysis of the planimetric accuracy of historical maps', in *e-Permetron*, i, no. 3 (2006), pp 239–45; Bernhard Jenny, 'Geometric distortion of schematic network maps', in *Bulletin of the Society of Cartographers*, xl (2006), pp 15–18; Bernhard Jenny, Adrian Weber and Lorenz Hurni, 'Visualizing the planimetric accuracy of historical maps with MapAnalyst', in *Cartographica*, xlii, no. 1 (2007), pp 89–94; David Raymond, 'Software review: MapAnalyst 1.2.1', in *Cartographica*, xlii, no. 1 (2007), pp 95–7. The evidence and the final results of this author's map accuracy test on the *Exact survey* are discussed in full in Montague, 'Exact survey of Dublin', chapter 5, and will be further elucidated in a proposed publication for *Imago Mundi* (John Montague, forthcoming).

60 A close street-by-street comparison between Rocque's original and Scalé's 1773 revision has been made in Montague, 'Exact survey of Dublin', chapter 5.

61 For the dissenter houses of worship recorded on the *Exact survey*, see Kenneth Ferguson, 'Rocque's map and the history of nonconformity in Dublin: a search for meeting houses', in *DHR*, lviii (2005), pp 129–65.

62 For detailed information and analysis of the 150-year period of topographical growth down to 1756, see Colm Lennon, *Dublin, part II, 1610–1756* (Irish Historic Towns Atlas, no. 19, Dublin, 2008).

63 Edward McParland, *Public architecture in Ireland, 1680–1760* (New Haven and London, 2001), pp 26–8.

64 Ibid., pp 91–113; J.B. Maguire, 'Seventeenth-century plans of Dublin castle', in *RSAI Jn.*, civ (1984), pp 5–14.

65 McParland, *Public architecture*, pp 185–203.

66 Rowena Dudley, 'St Stephen's Green: the early years, 1664–1730', in *DHR*, liii (2000), pp 157–79.

67 Gráinne Doran, 'Smithfield market — past and present', in *DHR*, l (1997), pp 105–118; Brendan Twomey, *Smithfield and the parish of St Paul, Dublin, 1698–1750* (Dublin, 2005), pp 10–24.

68 Niall McCullough, *Dublin, an urban history: the plan of the city* (Dublin, 2007), pp 41–51.

69 Nuala Burke, 'An early modern Dublin suburb: the estate of Francis Aungier, earl of Longford', in *Irish Geography*, vi (1972), pp 365–85.

70 David Dickson, 'Large-scale developers and the growth of eighteenth-century Irish cities', in Paul Butel and L.M. Cullen (eds), *Cities and merchants: French and Irish perspectives on urban development, 1500–1900* (Dublin, 1986), pp 109–24.

71 Christine Casey, *The buildings of Ireland: Dublin, the city within the Grand and Royal Canals and the Circular Road with the Phoenix Park* (New Haven and London, 2005), pp 498–504, 569–73.

72 Lennon, *Dublin, part II, 1610–1756*, pp 4, 6.

73 Ibid., p. 32.

74 Ibid., p. 6; Richard Castle, *An essay towards supplying the city of Dublin with water* (Dublin, 1735).

75 Lennon, *Dublin, part II, 1610–1756*, p. 6.

76 McParland, *Public architecture*, pp 53–72.

77 Ibid., pp 123–30.

78 Ibid., pp 144–65.

79 Ian Campbell Ross (ed.), *Public Virtue, public love: the early years of the Dublin lying-in hospital: the Rotunda* (Dublin, 1986).

80 Edel Sheridan, 'Designing the capital city, *c.* 1660–1810', in Joseph Brady and Anngret Simms (eds), *Dublin through space and time (c. 900–1900)* (Dublin, 2001), pp 78–80, 87.

81 Walter Harris, *The history and antiquities of the city of Dublin* (Dublin, 1766), pp 479–80.

82 Peter Walsh, 'Dutch Billys in the liberties', in Elgy Gillespie (ed.), *The liberties of Dublin* (Dublin, 1973), pp 58–74.

83 Ferguson, 'Rocque's map', pp 129–65.

84 Nuala Burke, 'A hidden church? The structure of Catholic Dublin in the mid-eighteenth century', in *Archivium Hibernicum*, xxxii (1974), pp 81–92.

85 Lennon, *Dublin, part II, 1610–1756*, p. 8.

86 Gary Boyd, *Dublin, 1745–1922: hospitals, spectacle and vice* (Dublin, 2006).

87 Máire Kennedy, 'Politics, coffee and news: the Dublin book trade in the eighteenth century', in *DHR*, lviii (2005), pp 76–85.

88 *Ancient records*, x, p. 252.

NOTES

PART II ~ Map extracts and commentaries

The original version of the *Exact survey* used for the extracts is in the Map Library, Trinity College Library, Dublin, and it is reproduced with the permission of the Board of Trinity College. See the editorial note on p. vi for further details.

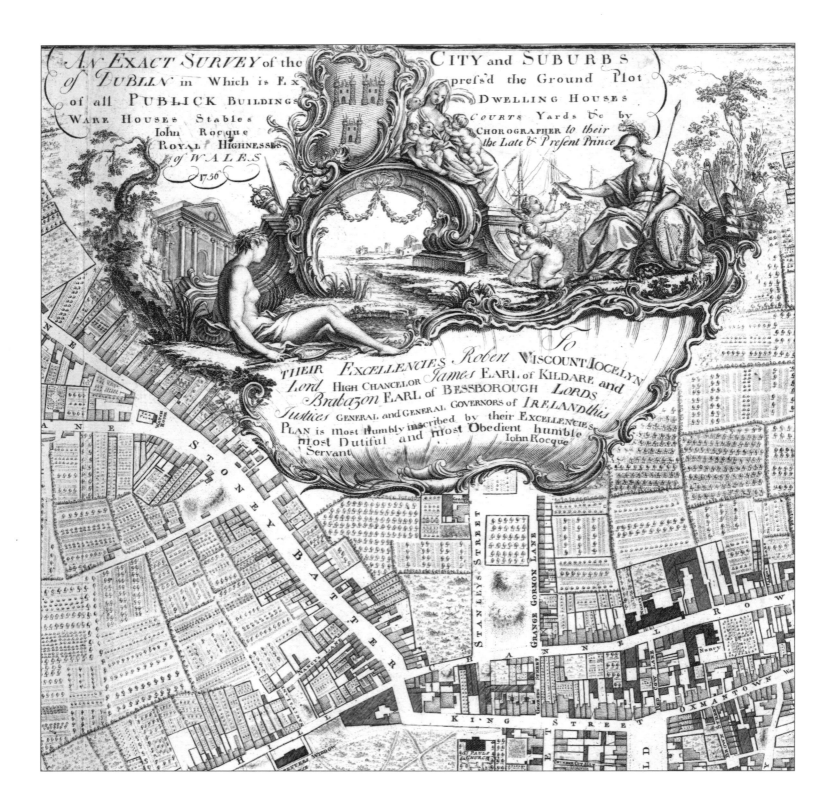

An EXACT SURVEY of the CITY and SUBURBS of DUBLIN in Which is Expres'd the Ground Plot of all PUBLICK BUILDINGS DWELLING HOUSES WARE HOUSES Stables COURTS Yards &c by John Rocque CHOROGRAPHER to their ROYAL HIGHNESSES the Late & Present Prince of WALES 1756

To THEIR EXCELLENCIES Robert VISCOUNT JOCELYN Lord HIGH CHANCELLOR James EARL of KILDARE and Brabazon EARL of BESSBOROUGH LORDS Justices GENERAL and GENERAL GOVERNORS of IRELAND this PLAN is Most Humbly inscribed by their EXCELLENCIES most Dutiful and most Obedient humble Servant John Rocque

STONEY BATTER

STANLEYS STREET

GRANGE GORMON LANE

KING STREET

ROW

OXMANTOWN

There are two cartouches on the *Exact survey*, both taking up a considerable quantity of ground in what otherwise would have been rural or undeveloped land surrounding the city. A cartouche is a graphical device commonly used on early modern maps to frame titles or other pertinent information about the map. Rocque's cartouches are characterised by their use of elaborate rococo motifs, a style of art that Rocque helped to introduce to Britain and through these maps, and his Kildare estate maps, to Ireland too. On the *Exact survey* the main title cartouche is located just above Grange Gorman House, the location in which the great nineteenth-century hospital complex that bears this name was to be built. The area covered by the cartouche is to the east of Cabra Lane (Aughrim Street) and Stoney Batter (Prussia Street) and to the west of what Rocque called Glasmanoge Road and the Road to Glasnevin (Grangegorman Upper).

This cartouche consists of an elaborate riverine scene populated by nymphs, *putti* and goddesses who, although unnamed, are easily identified. On the left bank, seated with her tiller in hand, is a river nymph who is the female personification of Dublin's river, Anna Liffey. She sits on the river bank among the rushes, but in the middle distance a quatrastyle Ionic portico is likely to be that of Edward Lovett Pearce's Parliament House (see **18**); the small circular contour above the pediment may be an awkward effort at suggesting its dome. Just above the river nymph's head, the parliamentary mace and the sword of state project from a rocaille bridge.

On the right-hand bank is a Minerva figure with helmet, spear, shield and cornucopia. Minerva was commonly used as a national personification of Britain and, with the harp on her shield rather than the Union Jack, we can assume that in this case the figure is Hibernia. She is handing books and surveying instruments to a pair of *putti* or cherubs (Fig. 6, right). Between the two sets of figures, a typically Rocquian cluster of busy rococo patterning bridges the river. It is crowned by the three-flaming-castles arms of Dublin city, against which a female figure, representing Dublinia, leans. She suckles a small *putto* and another play-

fully throws his bread in the direction of Hibernia. The awkwardly rendered figure also represents the figure of Charity, although at a stretch the two *putti* might be imagined as the Romulus and Remus of the Irish capital.

Above this elaborate allegorical scene representing Ireland, Dublin and the Liffey in turn, and below contained within a shell-like frame are the titles of the map: *An exact survey of the city and suburbs of Dublin, in which is express'd the ground plot of all publick buildings, dwelling houses, ware houses, stables, courts, yards &c … .* The ambition of this map, in which every back yard and outhouse as well as all of the dwelling houses and public buildings were to be recorded individually, is proclaimed here. This was in complete contrast to any other map Rocque had produced to date or (with the exception of the Armagh city and Newry insets within the Armagh county map) afterwards. Rocque's great London map of 1747, for which he was most renowned, was confined to the city block, as was Brooking's 1728 map of Dublin. London had to wait for Horwood's 1792 map to get equal cartographical detail and the next such map for Dublin was created by the Ordnance Survey in the 1840s. In the lower frame Rocque dedicated the map to the three lords justice, Robert Viscount Jocelyn, James earl of Kildare and Brabazon earl of Bessborough, who in the absence of the lord lieutenant acted as Ireland's chief governors.

Fig. 6: Detail from title cartouche of the *Exact survey*.

1. TITLE CARTOUCHE

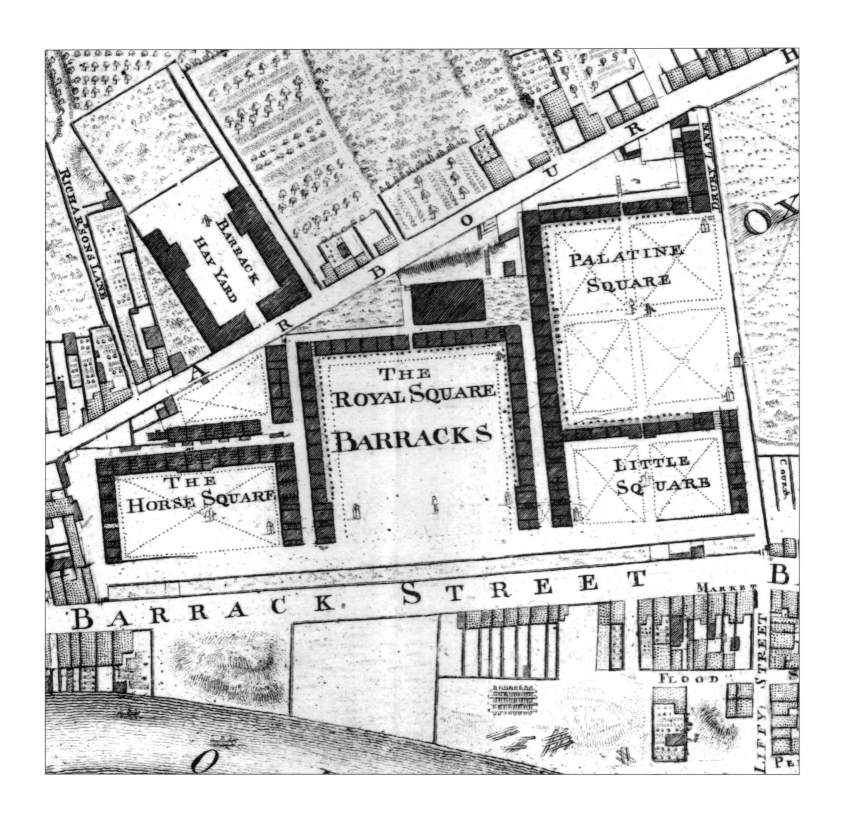

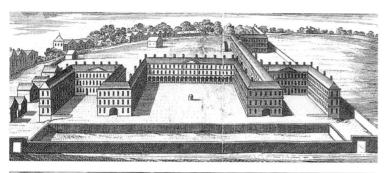

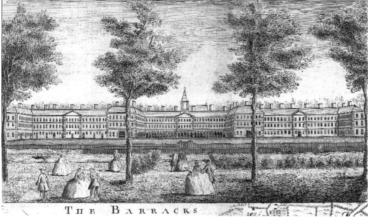

▲▲ Fig. 7: Royal Barracks, from Charles Brooking, *A map of the city and suburbs of Dublin* (1728).

▲ Fig. 8: Royal Barracks, from John Rocque, *Survey of the city, harbour, bay and environs of Dublin* (1757).

The most important building for the military garrison at Dublin was the Royal Barracks (Collins Barracks), constructed on Oxmantown Green (see **3**) in the city's north-western sector just after 1700. Unlike previously erected barracks, this edifice was a free standing entity, one of the earliest of its kind in Europe. The project, which was on a scale unmatched in other public commissions, brought a new overseeing body, the Barrack Board, into being and the state's surveyor-general, Sir Thomas Burgh, was the architect. Construction went ahead on a site that had been sold to the state by the second duke of Ormonde (who was then lord lieutenant as his grandfather had been). The building was completed in 1708, by which time the barracks was ready to receive up to two foot regiments and three troops of horse in three-storey buildings, stretching for 1,000 feet along the river (Figs 7, 8, left). Part of the large complex was to accommodate a house cavalry and the stables in Horse Square (Cavalry Square) located on each of the three sides were fitted out for approximately 150 horses, each stall containing a trooper's quarters above. The Horse Square had been completed by 1732 and in 1756 there were also incorporated within the complex the Palatine Square and the Little Square as well as the central Royal Square, all shown on Rocque's map. Separated from the main complex by the diagonal of Arbour Hill was the Barrack hay yard. The chapel was built about 1746 but was almost immediately turned into a riding school. This steepled building, which appears on the map as a rectangular block directly north of Royal Square, had a roof span of 59 feet (18 metres). With the erection of the barracks, the burdensome practice of quartering troops in private housing in the city and suburbs of Dublin came to an end. The officers normally dined in taverns, while the men cooked in their lodgings. Not only did the new building bring further architectural distinction to the northern periphery of the city, it also stimulated commercial activity, particularly in the newly developed Smithfield and Ormond Markets. As a side-effect, the seal was set on the nature of the development in the Oxmantown Green area, which never attained the residential fashionability of St Stephen's Green (see **22**, **24**), for example, despite the proximity of the recently enclosed Phoenix Park. Today the barracks buildings are part of the National Museum of Ireland and provide exhibition space for the museum's collections.

 2. THE ROYAL BARRACKS

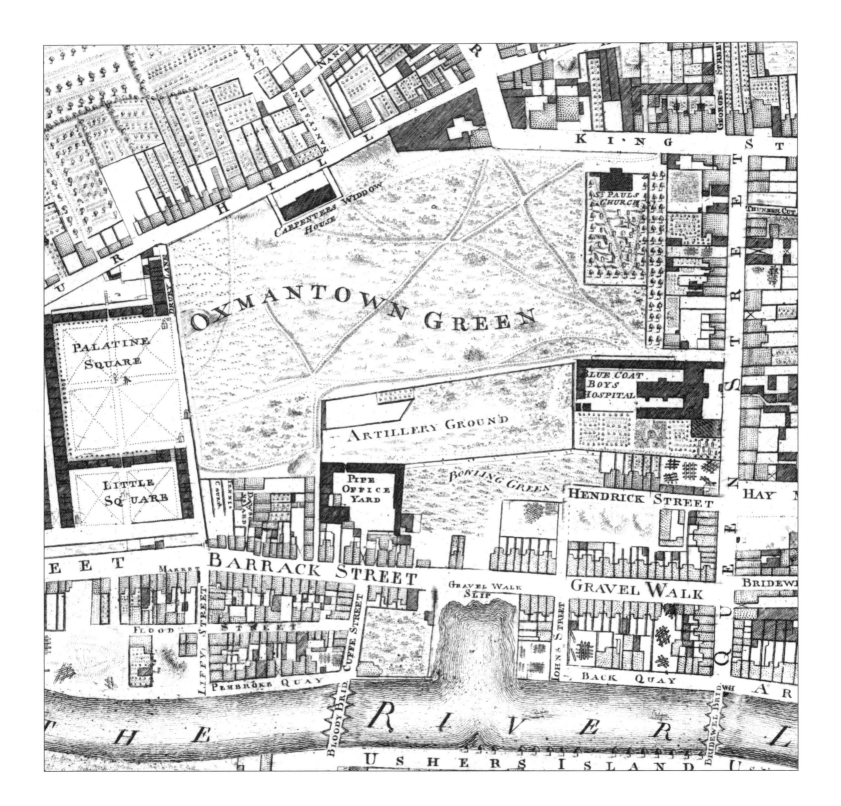

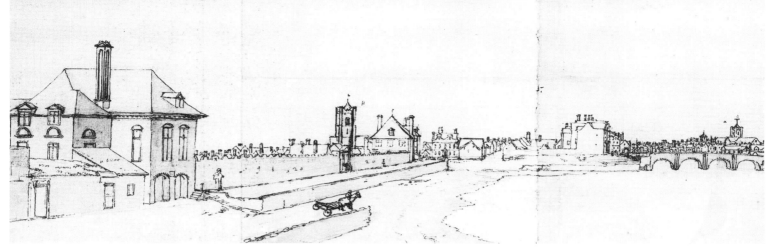

Fig. 9: View of the city from the Wooden or Bloody Bridge, 1698, by Francis Place (National Gallery of Ireland). The bridge depicted is the Bridewel (later Mellowes) Bridge on the *Exact survey*.

In Rocque's depiction of Dublin in 1756, the only extensive piece of medieval commons remaining is Oxmantown Green in the north-west of the city. The other residual commonage area shown is Little Green north-east of Oxmantown, but only a very small fragment survives. The earlier open public spaces of Hoggen Green and St Stephen's Green have been intensively developed, the former as a major urban concourse and the latter as a private residential square.

Yet the green of Oxmantown, which had been intact as a commons less than a hundred years earlier, was in the interim encroached upon by many buildings and urban facilities, some of which are the subject of other vignettes in this volume. A bowling green to the south dated from 1664 (Fig. 9, above), at a time when the city council was attempting to develop the nearby Smithfield (see **4**) as a residential project for the north side, along lines similar to those devised for St Stephen's Green on the south. A bridewell, and later house of correction, was established to the south of Smithfield also in the 1660s, the forerunner of the institution that came to be located at Mount Brown (see **37**). The Blue Coat Boys Hospital (King's Hospital) was founded in 1671 on Queen Street E., on the eastern side of Oxmantown Green and the church of the new northside parish of St Paul was erected to the north of the school by 1702. The area became the heart of the military establishment, the construction of the Royal Barracks building (see **2**) along the river front of Oxmantown in the early 1700s being preceded by the appointing of the artillery ground in the heart of the green in 1676. The laying out of the barracks squares in succeeding decades swallowed up more ground and gave rise to ancillary riverside development. Two additional administrative facilities had

been located on Oxmantown Green by 1756: the Carpenters' Widows House to the north and the Pipe Office Yard of the city council to the south.

The evidence suggests that the city council had aspired to create an exclusive residential enclave in Oxmantown at the time of its division into 99 lots in 1665. The plan was for the lessees to undertake development of their plots by building substantial houses. But the district never achieved the fashionableness of the contemporaneous municipal project for St Stephen's Green (see **22**). A grant of seven acres of land in the west of Oxmantown Green was made to the duke of Ormonde, the cultural arbiter of Restoration Dublin, in anticipation of his building a palace there that would attract the residence of other grandees. Ormonde never moved across the Liffey, however, and, although some elegant mansions were constructed by the aristocratic lessees of plots on the square at Smithfield, the district came to be dominated by commercial interests. The proximity of the markets in cattle and hay in Smithfield, and fish, poultry and butter in the Ormond Market (see **8**), as well as the establishment of institutions of confinement and charity in the vicinity of the green probably deterred more affluent private residents from setting up home in the area.

The district of Oxmantown Green came to be cramped within a triangular shape formed by Barrack Street (Benburb Street) to the south parallel to the river, Queen Street to the east and the diagonal of Arbour Hill running towards the Liffey in the west. When mapped in 1756, the remaining green area appeared as a negative space of irregular parkland left over after the haphazard intrusions of school, barracks, church, almshouse, pipe yard, bowling green and some housing.

 3. OXMANTOWN GREEN

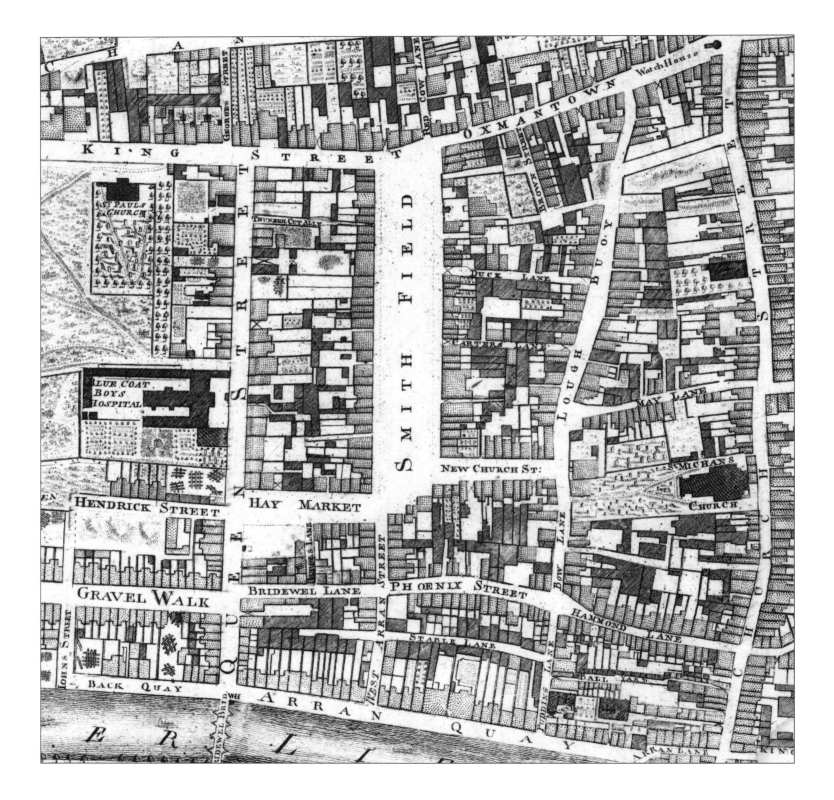

CH A

KING STREET

GEORGES STREET

RED COW LANE

OXMANTOWN

WatchHouse

BROWN STREET

ST PAULS CHURCH

THUNDER CUT ALLY

STREET

SMITH FIELD

DUCK LANE

CARTERS LANE

LOUGH BUOY

MAY LANE

BLUE COAT BOYS HOSPITAL

SS MICHANS CHURCH

NEW CHURCH ST:

HENDRICK STREET

HAY MARKET

GRAVEL WALK

QUEEN STREET

BRIDEWEL LANE

JERVIS LANE

ARRAN STREET

PHOENIX STREET

BOW LANE

HAMMOND LANE

STABLE LANE

PUDDING LANE

BALL ALLY

JOHNS STREET

BACK QUAY

BRIDEWEL BRIDGE

WEST

ARRAN QUAY

ARRAN LANE

KING

E R L I F F E

Smithfield is shown as a prominent urban space in Oxmantown on Rocque's map. Like its London counterpart from which it derived its name, Dublin's Smithfield had become the centre of the cattle trade in the city, having absorbed the site of the bridewell which was transferred to Kilmainham in 1730 (see 37). Originally planned in the 1660s as a residential suburb on city land on the north side to match St Stephen's Green (see 22) on the south, the precinct dominated by the large rectangular shape of Smithfield was central to the development of a grid of a dozen streets and lanes between 1665 and 1718. Somewhere on the former Oxmantown Green, however, a cattle market had been in operation since 1541 and the newly laid out and paved Smithfield and the Hay Market directly south of it continued to house marketing facilities in meat, hay and livestock.

At first, the district was to have housed the very best of Dublin society. Plots for development were granted by the city to three peers, three baronets, nineteen 'gentlemen', seventeen aldermen and fifteen merchants. Among the aristocracy who established themselves here was Sir Thomas Taylor of Kells, Co. Meath, later earl of Bective, whose imposing five-bay townhouse designed by Richard Castle stood on the western side of the square (the fourth building south of Thunder Cut Alley). Taylor had an interest in the cattle trade and was a breeder of horses. Access to his house and the large backyard could also be had from Queen Street, where Rocque has shown two ranges of significant outbuildings accessed via arched entries, as indicated by the X-shaped symbol common in architectural drawings and maps, then and since. These buildings might have been used for housing cattle before they were brought to market or for his horses.

The 'stables belonging to the Right Hon'ble Sir Thomas Taylor, Bart' were of sufficient scale to have been used in a 1754 *Dublin Journal* advertisement as a landmark for guiding traders to the nearby wine 'vaults' in Queen Street.

Such merchant trade in wine and other foodstuffs ran in parallel to the livestock trade and no doubt there were benefits to their proximity. However, almost a third of the original 99 plots established by Dublin Corporation were granted to artisans. Small industry became, in time, a dominant feature of the area, in particular small breweries. At one point a tax for the upkeep of the pavement was proposed by the corporation on brewers who kept carts with iron wheels. It was also suggested that a contribution be made to the King's Hospital of a barrel of table beer for every cart load sold. The Blue Coat Boys Hospital or King's Hospital was built on a site set aside among the original plots on the west side of Queen Street. Designed for the dual purpose of a refuge and school for young boys as well as for the destitute elderly, one of its earliest sponsors William Smith, the lord mayor, was himself dependent on its charity in his old age and was appointed steward of the school until his death in 1684. Erected in 1669–73, the building as recorded by Rocque had been expanded in the 1740s to the designs of Richard Castle. The school later moved to a building designed by Thomas Ivory in 1772–3 on a new site. According to Rocque, the school had direct access along a tree-lined avenue to the church of St Paul set in its own grounds on the south side of King Street. This was built in the opening years of the eighteenth century for the new parish of St Paul established in 1697 to facilitate the burgeoning new suburb centred on Smithfield.

4. SMITHFIELD

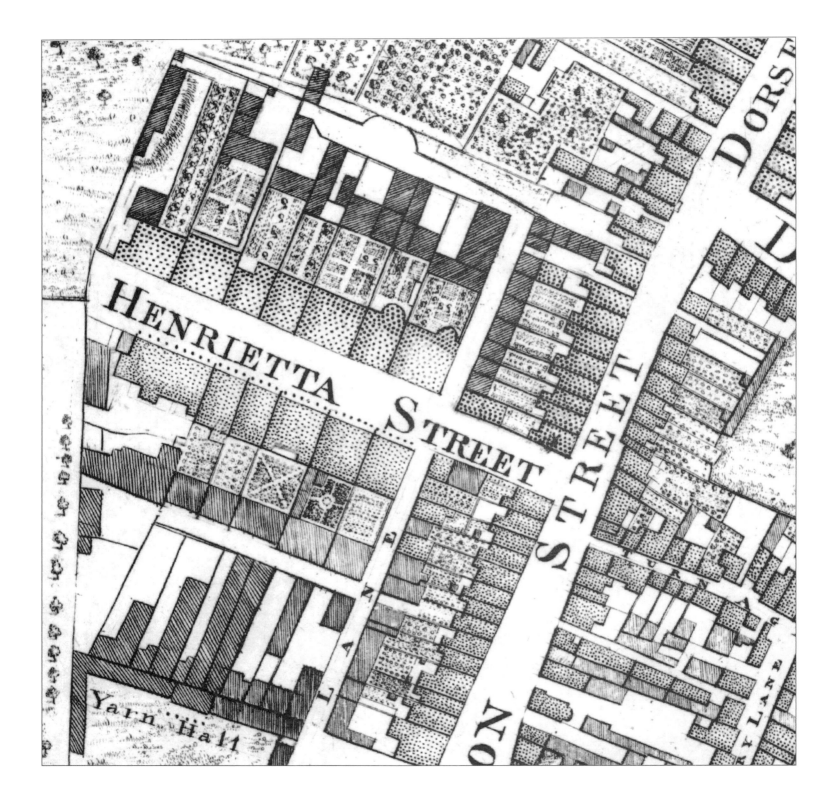

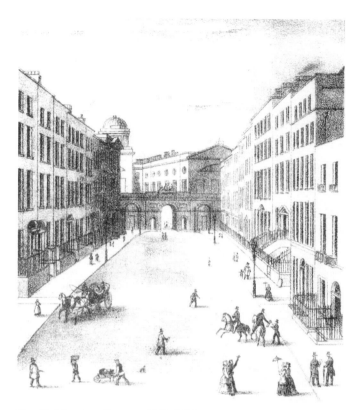

Fig. 10: Henrietta Street, *c.* 1850 (NLI).

Henrietta Street was perhaps the grandest of all streets in the Dublin depicted by Rocque in 1756. Laid out in 1721 by Luke Gardiner at the north-western edge of his north-city estate, it comprised lands once belonging to St Mary's Abbey. Predating his later Sackville Mall (see **14**) by some thirty years, Gardiner built a house for himself here, on a street that accessed the south centre city by way of Bolton Street, Capel Street and Essex Bridge (see **11**). The terraces of palatial houses on both sides of the street were built between 1724 and 1755. The earliest building on the map was the townhouse for the archbishop of Armagh, Hugh Boulter, on the south side of the west end of the street. Boulter's house set the tone and scale for the other houses, and it was Boulter who dictated that the street be at least 50 feet wide 'from the railes to be set before the houses'.

The primate's house remained the largest of an ensemble of enormous, four-storeys-over-basement four- and five-bay houses, built to the new classical style of modest red-brick exteriors with straight parapets, enclosing sumptuous stuccoed and timber panelled interiors. Gardiner's house was built, possibly to Richard Castle's designs, in *c.* 1730 directly opposite the prelate's house and some elements of its interior survive. To the east, Edward Lovett Pearce, the architect of the Parliament House (see **18**), designed a house for Thomas Carter, master of the rolls, in 1731–2, copying closely Lord Burlington and Colen Campbell's design for Lord Mountrath's house in Old Burlington Street in London. In contrast to that London street, however, its Dublin equivalent has remained largely unaltered and is a rare example in these islands of the preservation of an early eighteenth-century ensemble of this quality and scale (Fig. 10, left).

Luke Gardiner's colleague, Nathaniel Clements, also lived on Henrietta Street and was responsible for the development of houses on the north and south of the street. Rocque gives suggestive details for the gardens of the houses and also depicts the stable and coach houses to the rear, with a range of these on both sides of a stable lane on the south side of the street. The row of dots shown on Henrietta Street depicts bollards separating the footpath from the road, similar to those on Sackville Street, and should not be confused with the same symbol used elsewhere on the map to indicate columns.

 5. HENRIETTA STREET

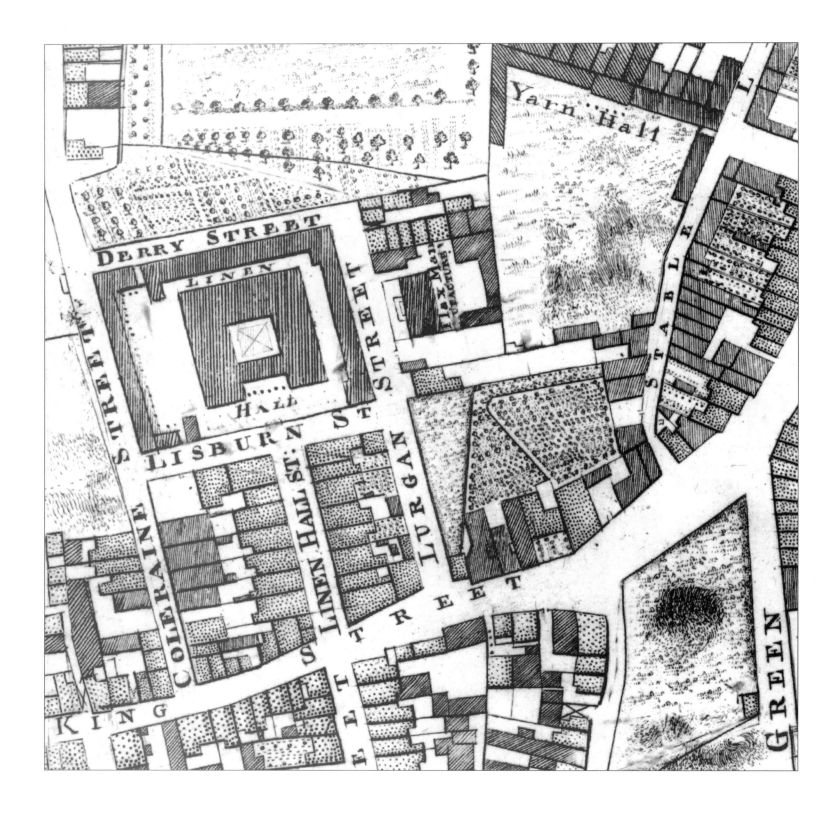

DERRY STREET

Yarn Hall

STREET

LINEN

Hall

Flax Manufactory

STREET

LISBURN ST

STABLE

COLERAINE

LINEN HALL ST

LURGAN

STREET

KING

STREET

GREEN

On the northern perimeter of the city as depicted by Rocque there lies a complex of buildings and streets associated with the early eighteenth-century linen industry in Dublin and centred on the Linen Hall. On the three-acre site, which is bounded by streets redolent of places of linen production in Ulster — Coleraine, Lisburn, Derry and Lurgan — there is also a yarn hall and a flax manufactory. Here potentially was an industrial hub to counterpoint that evolving in the earl of Meath's liberties in the south-west of the city.

A Linen Board had been established to control the trade in 1711 and in the early 1720s a search for a suitable site for a linen hall was initiated. The Bolton Street area recommended itself as being popular with travelling traders in linen and a three-acre site was acquired for a new building. It was designed by Thomas Burgh and, as in the case of the Royal Hospital (see **39**) and Dr Steevens's Hospital (see **38**), the influence of architectural models elsewhere was brought to bear, specifically Blackwell Hall in London and the Cloth Hall in Hamburg. When it opened for business in 1728, after six years of construction, the Dublin Linen Hall was a square building with an inner courtyard set within a larger yard, the western side of which consisted of a colonnaded loggia used by the cloth sellers (Fig. 11, above right). It contained a large trading hall, 550 compartments or bays for storage of cloth, a boardroom for meetings of the Linen Board, and a large, elegant coffee-room in which traders and factors could transact their deals. The Linen Hall had an efficient administrative management system, a chamberlain overseeing all aspects of the building's functions, and a gate-keeper, clerk, porters and watchmen to supervise daily business and security.

By Rocque's time, a yarn hall and a flax manufactory had been added to this linen industrial estate. The Linen Hall building itself was enhanced under the auspices of the architect, Thomas Cooley, in the later eighteenth century, but the opening of the Belfast Linen Hall in 1783 greatly detracted from the standing of its Dublin counterpart and the Linen Board was dissolved in 1828. The hall became a barracks in the late nineteenth century, and later, on being taken over by the Board of Works, was used as the venue for the Dublin Civic Exhibition in 1914. The building was destroyed by fire during the Easter Week insurrection in 1916 and only a rusticated granite entrance arch remains as a relic of a once-important industrial complex.

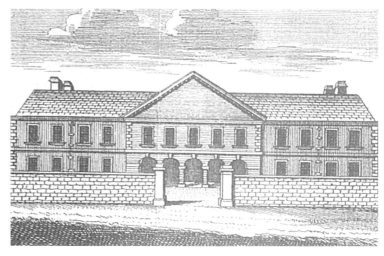

Fig. 11: Linen Hall, from Charles Brooking, *A map of the city and suburbs of Dublin* (1728).

6. LINEN HALL

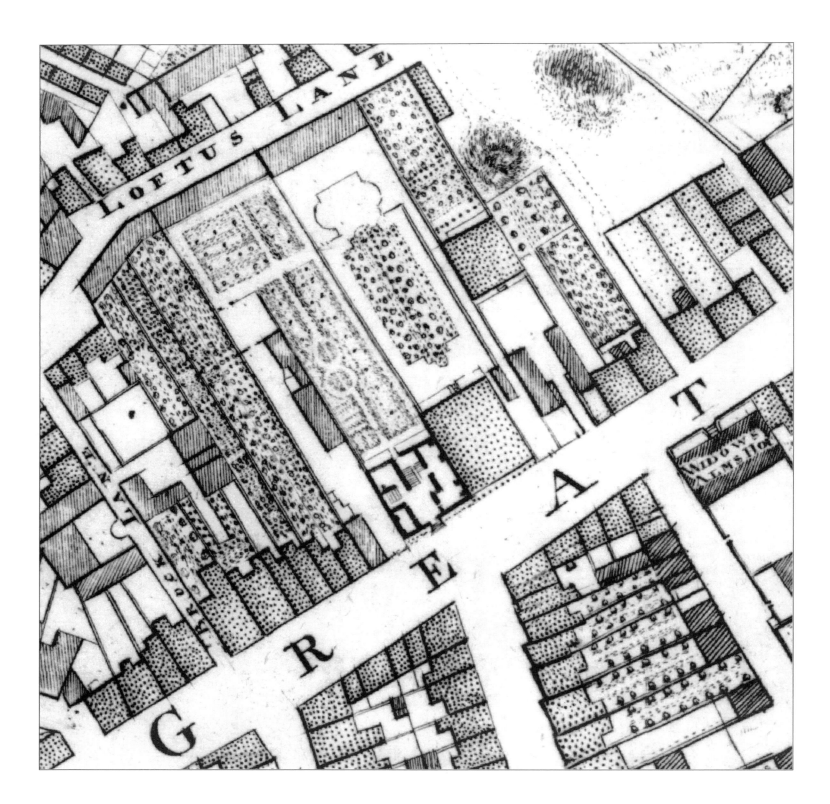

We do not know why Rocque decided to come to Dublin and whether, as he implied in an early advertisement for the *Exact survey*, he was invited by some influential society figure. It is clear, however, that he was quick to ingratiate himself with men of importance in the city. His first public display of an India ink draft of the map was to the court of the lords justice, some three months after he first arrived in the city, and this early outing resulted in a very large collection of subscriptions for the proposed *Exact survey*. A key player in intellectual circles in Dublin at this time was the wealthy landowner, John Putland (1709–73), treasurer to the Dublin Society and an active member of the Dublin Physico-Historical Society. It seems likely that he was an early local confederate of Rocque, if for no other reason than that Putland's house is the only dwelling house, and indeed the only building other than the Parliament House (see **18**), for which Rocque provided an internal ground plan on the 1756 map. Not only was this a compliment to Putland — himself an avid collector of architectural books — but it also implies that Rocque was familiar with the interior of Putland's house. Two of Rocque's later editions of his *Exact survey* were dedicated to John Putland and to his brother George — the parishes map and the pocket plan, both published in 1757. In London, Rocque had been provided with considerable institutional support from the corporation and from the Royal Society with regard to technical aspects of surveying on the ground, as well as with the establishment of street names and other topographical points. Rocque had no such institutional or official support in Dublin and so it is likely that individuals such as Putland

or James Simon, a member of the Dublin Society and London's Royal Society, and a known associate of Rocque in Dublin, may have helped him to get a timely feeling for on-the-ground information, local names and where for example to establish his base-line measurements.

Putland's house (north of the 'E' in 'GREAT') was one of a set of three large houses with extended landscaped gardens to their rear on the north side of Great Britain Street (Parnell Street) in the north-east of the city. It was built on axis with Jervis Street, one of the most important on Jervis's estate (see **8**), laid out in the 1670s and 80s. The site was purchased in 1709 by Putland's grandfather, Thomas, a cashier to Sir William Robinson who had accumulated an enormous landed estate in Counties Meath and Cork, and in Dublin city. The house, which was replaced by Simpson's Hospital 'for blind and gouty men' in the 1780s, and in the twentieth century by Williams and Woods sweet factory, was probably five bays wide with an entrance hall leading to a grand staircase at the centre of the house and rooms on either side, to the rear and the front. Consistent with the fact that the internal plan was being recorded here, this is one of the few houses on the map where the basement area and bridging steps across it are recorded. The figure-of-eight parterre in the garden to the rear is also likely to have been based on observed evidence, as are the layout of stables and gardens for each of the three houses. What might have been fruit gardens at the very end of Putland's property stretch across what look like two sites fronting the street, implying that the outbuildings here, arranged in a kind of *basse-cour*, were also inside the curtilage of Putland's domain.

7. PUTLAND HOUSE

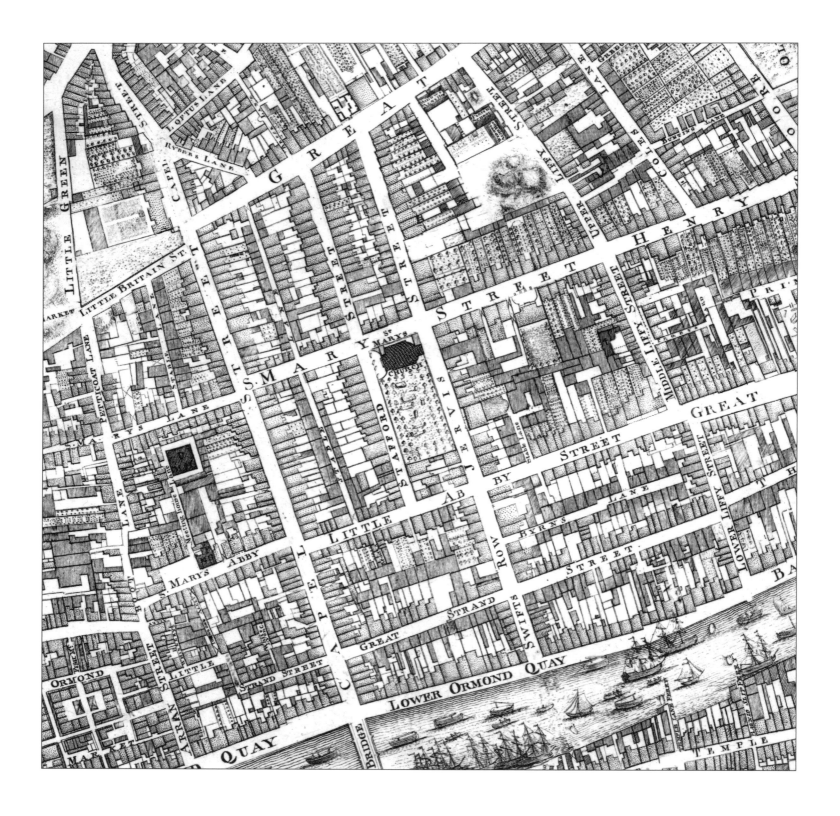

Although by 1756 the urban estate developed in the late seventeenth century by Sir Humphrey Jervis had been fully absorbed within the suburban expansion on the north bank of the Liffey, the original grid of nine (3 by 3) major blocks, as envisaged by Jervis in his surviving estate plan, can still be discerned on Rocque's *Exact survey*. The area encompassed by Jervis's first plan stretched from the line of Arran Street (Arran Street East)/Boot Lane (Arran Street West)/Petticoat Lane (Little Green Street) in the west to Liffey Street in the east, and was confined between Ormond Quay on the river and the line of Great Britain Street (Parnell Street) to the north. These nine blocks were partially subdivided, to provide stable lanes for access to the mews and carriage blocks of the grand houses fronting onto the major streets. A portion of the central square was left open from the start, to provide a public space, and this was filled by St Mary's Church and graveyard in the first decade of the eighteenth century. Although conceived as a suburb to the city on the north side of the river, the nine-square arrangement was a paradigm of colonial town-plans at the time and may be compared to that of New Haven of the 1630s, or to Robert Newcourt's complex amalgam of nine-square grids for his utopian plan for the rebuilding of London after the great fire of 1666. Jervis's initial nine-square projection was expanded westwards to the line of Charles Street/Fishers Lane (St Michan's Street)/Georges Hill and included the Ormond Market, itself designed around a perfectly square grid. This market replaced the former city market located at Fishamble Street, south of the river, and is in turn the ancestor of the fruit and vegetable wholesale market that survives today a little to the north of the seventeenth-century site. Two new bridges joined this development to the south bank and the older urban areas — Ormond Bridge (O'Donovan Rossa Bridge) linking Charles Street and Wood Quay, and Essex Bridge (Grattan Bridge) connecting Capel Street and Custom House Quay. At the heart of the new suburb lay the church of St Mary, taking its name from the Cistercian abbey on the lands of which Jervis had built his estate. Quays, bridges, parish church and regularly aligned streets had all contributed to the successful creation of a city quarter and its connectivity to the wider urban world. The speed of the construction of its lineaments was attested by the two late seventeenth-century maps of de Gomme (1673) and Phillips (1685): in the twelve years between the two surveys, the Jervis suburb had taken shape on the lands designated simply as 'abby parkes' (Fig. 12, below).

Fig. 12: Development of the Jervis estate between Bernard de Gomme's map (National Maritime Museum, Greenwich) of 1673 (left) and Thomas Phillips's map (BL) of 1685 (right).

 8. JERVIS ESTATE

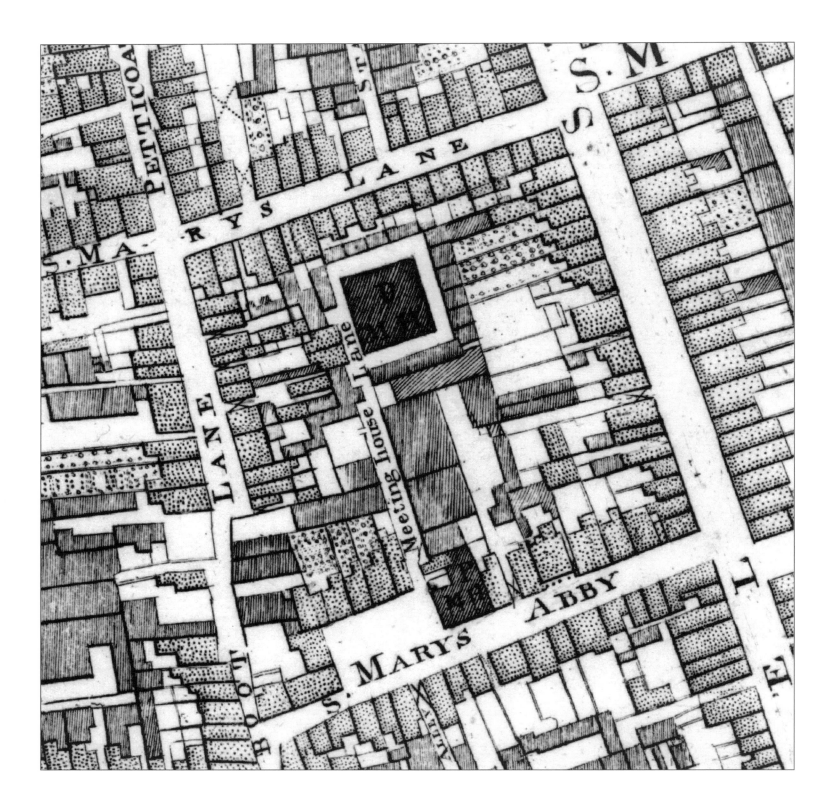

In the heart of the Jervis suburb on the north bank of the Liffey, Rocque depicted an urban block framed by St Mary's Lane to the north, St Mary's Abbey to the south, Boot Lane (Arran Street East) to the west and Capel Street to the east. Featured within the rectangle thus formed were two Presbyterian meeting houses (PMH) joined by Meeting House Lane, to the east of which, but unnamed, is shown the chapter house of St Mary's Abbey. As well as evidencing the evolution of streetscapes, the map gives a perspective on the changing religious affiliations of residents in the quarter.

The street nomenclature is resonant of the great abbey that occupied the lands to the north-east of Dublin until its dissolution in 1540. In de Gomme's map of 1673 the 'abbey parkes' are shown as largely undeveloped, though Boot Lane appears as part of an extended St Mary's Lane. Twelve years later, Phillips's map shows the rapid development of the area, with the block under review formed, though with as yet unnamed streets. The names of the four framing thoroughfares were definitely established by the end of the first decade of the eighteenth century, Capel Street being denominated as early as 1687–8. The designation Meeting House Lane occurs for the first time on Rocque's map.

The only substantial relic of the medieval monastery buildings of St Mary's was and is to be found in this quarter — the chapter house. The site appears as a warehouse to the east of Meeting House Lane (to the right of the word 'house'), the chapter house being the cellar area beneath. It does not seem to have been associated in Rocque's day with any religious community. The Roman Catholics of the north inner city had as their nearest centre of worship in a chapel farther west along St Mary's Lane. Not until the late nineteenth century was the chapter house excavated and its significance discovered.

The largest site in the block at the northern end of Meeting House Lane was occupied by the Presbyterian meeting house, known as the Capel Street Meeting House. This was because it was accessible through an entrance from that street. This worshipping congregation dated back to 1667 and was one of the earliest of the denomination in the city. It later moved to Rutland Square (Parnell Square) where it retained in its name the association with its former premises, being called the Abbey Presbyterian Church.

There was another Presbyterian meeting house depicted by Rocque at the entrance to Meeting House Lane, just to the east of its junction with St Mary's Abbey, the name of which it took. The premises had formerly been a place of worship for French Huguenots who had leased it from Sir Humphrey Jervis in 1701. They continued to meet there until August 1740. By Rocque's time, the building had been taken over by a group of non-subscribing Presbyterians who had seceded from the nearby Capel Street congregation. In the nineteenth century, a third Presbyterian meeting house was established in this block, located on the opposite side of the entrance to Meeting House Lane in Mary's Abbey. This later became a synagogue.

Thus a site framed by streets whose names are redolent of a former monastery was itself a microcosm of the rich confessional life of the community of early modern Dublin.

9. ST MARY'S ABBEY

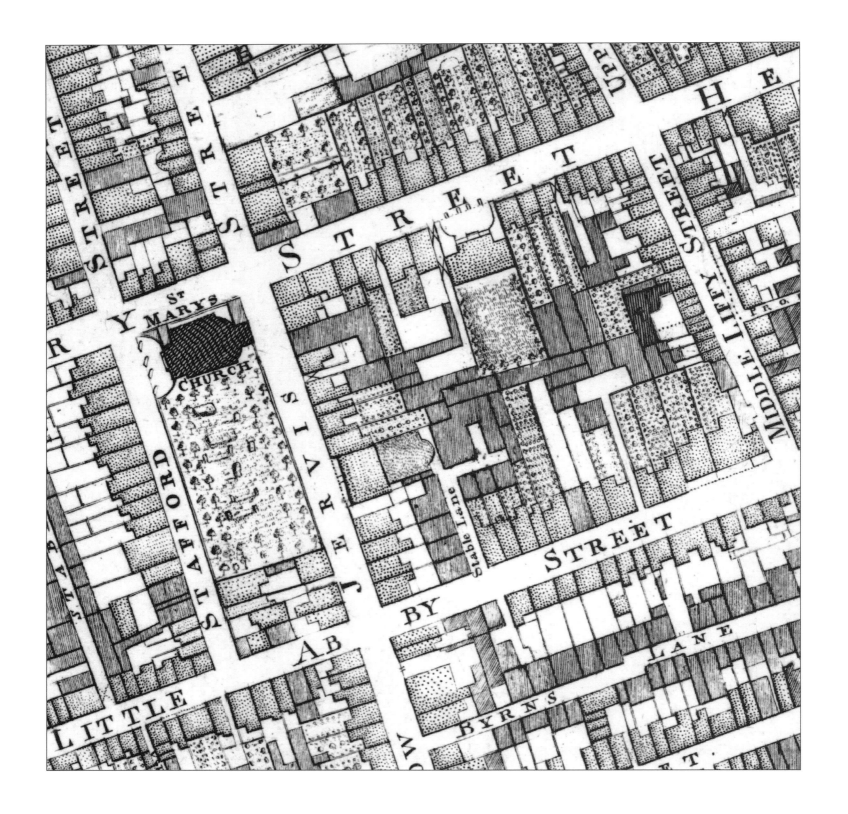

Rocque's depiction of the urban block enclosed between St Mary Street to the north, Little Abbey Street (Abbey Street Upper) to the south, Stafford Street (Wolfe Tone Street) to the west and Middle Liffey Street (Liffey Street Upper) to the east provides a fascinating insight into the social and political makeup of this suburb in the 1750s. The principal public monument is St Mary's Church of Ireland (Fig. 13, below). That this is a public building is indicated on the map by the cross-hatch shading used by the engraver and also by the bold letters stating the name of the church. In 1697 St Mary's parish, alongside St Paul's to the west, was established as an offshoot of the previously all-encompassing St Michan's in order to accommodate the burgeoning new suburb laid out in the 1670s and 80s by Humphrey Jervis (see **8**). The name of the parish picks up on the medieval Cistercian abbey of St Mary, upon whose lands the Jervis estate was founded. The church itself boasts a very impressive baroque east window, carved by John Whinnery to surveyor-general William Robinson's designs, on what was otherwise a fairly plain exterior.

Rocque takes special care in illustrating the attached burial ground, with its avenues of trees and its upright graveslabs, as well as a set of bollards to the front of the church depicted illusionistically in a three-dimensional form. This may be compared to the map-maker's treatment of the Roman Catholic church — also St Mary's — only one block to the east, indicated by a cross symbol and located just west of Middle Liffey Street. The subordinate character of this building is indicated by the simple cross shape inscribed within the shaded plan — this time a single diagonal hatching. That Rocque included this building, and indeed virtually all places of Christian worship in the city, is remarkable in itself. Its siting behind a block of small commercial and dwelling houses on Liffey Street is extraordinary. This church, like many other Catholic chapels of the time, did not address the street directly, but access was gained instead through a dwelling house or shop, perhaps in the possession of the parish. Despite the mixed nature of this commercial zone, the block between Jervis Street and Middle Liffey Street also boasted two important townhouses, both unnamed on the map: Langford House south of St Mary Street, whose quadrant entrance walls echo those of the Protestant St Mary's, and the residence of the earl of Charlemont on the east side of Jervis Street where he resided before he built his grand palace on the north side of Rutland Square (Parnell Square) in the 1760s.

Fig. 13: St Mary's Church of Ireland, *c.* 1900 (NLI).

10. ST MARY'S — CHURCH OF IRELAND AND ROMAN CATHOLIC CHURCHES

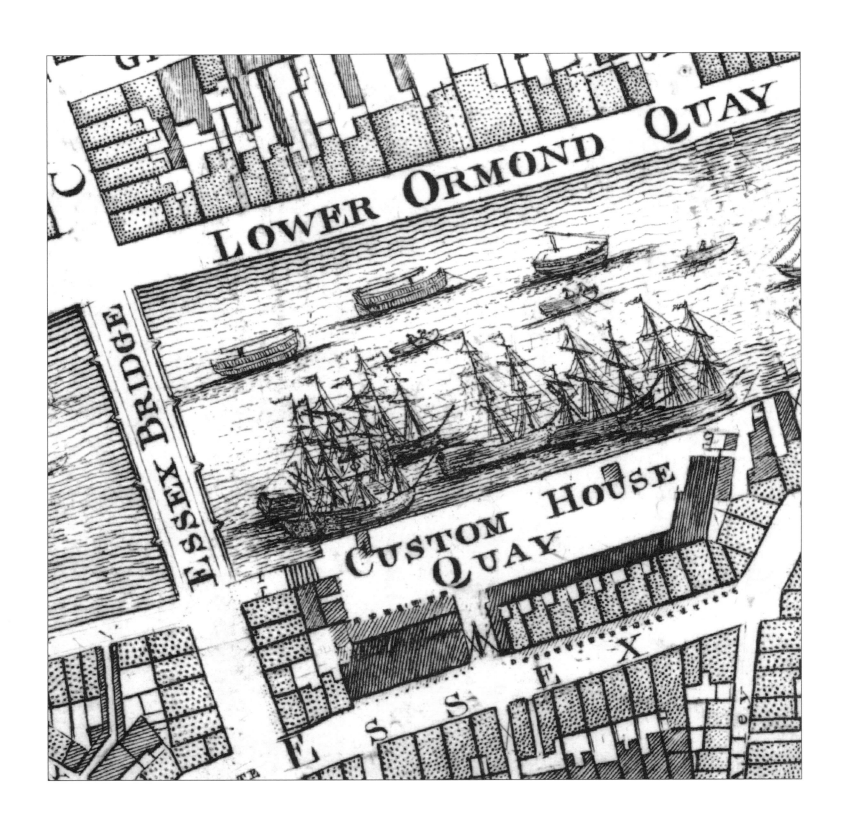

In the middle of the eighteenth century, Essex Bridge (Grattan Bridge) was the most easterly crossing point on the Liffey. The bridge held a pivotal position in controlling the location of the commercial centre of the city. The old Custom House — the one that served before Gandon's great masterpiece was constructed farther east in the 1780s — was on the south bank of the river just below the bridge and consequently at a point beyond which tall ships could not proceed. The first bridge in this location — named after Arthur Capel, earl of Essex and lord lieutenant of Ireland — was built in 1676 by Sir Humphrey Jervis in order to give direct access from his new suburb (see **8**) on the north side of the river to the heart of the old city in the south. Even then, the construction of the bridge was resisted by the citizens of the old city, for fear of the commercial loss of power that would result from Jervis's new suburb. Any attempts afterwards to build a bridge farther east were also aggressively resisted and it was not until almost 130 years after Jervis's bridge, that Carlisle Bridge (O'Connell Bridge) was opened to traffic in 1795.

The Custom House as shown on Rocque's map was the third such building in that location since the land had been reclaimed there in the first decades of the seventeenth century. The zone marks the ancient confluence of the Poddle and Liffey, and had great strategic importance in Viking times and afterwards. The three-storey Custom House with its high dormer roof and arcaded ground floor, as shown in Joseph Tudor's 1753 image (Fig. 14, below), was built in 1704–6 to the designs of surveyor-general Thomas Burgh, architect of the library in Trinity (see **19**) and the Royal Barracks (see **2**). All goods imported into, or exported from, Dublin were by law bound to pass through the Custom House where a tariff was paid. A great quay is shown to the front of the building where these goods were processed. A diagonally shaded block of storage sheds is depicted on the eastern side of the quay.

In 1687 a flood caused the collapse of Jervis's bridge, with the loss of a hackney and two horses. Only partially repaired, it was replaced in 1753–5 by a new bridge built by George Semple and modelled on Charles Labelye's recent Westminster Bridge. The statue of George I, erected in 1722 on its own pedestal west of the bridge, was not reinstated, despite its inclusion in the Tudor print.

Fig. 14: Custom House and Essex Bridge, 1753, Joseph Tudor.

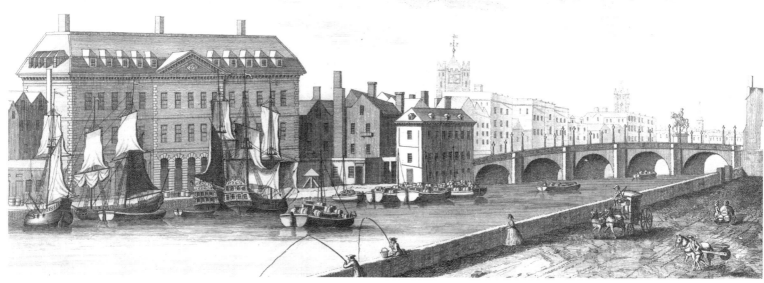

11. ESSEX BRIDGE AND CUSTOM HOUSE QUAY

Custom House Quay was the site of an earlier Custom House than that built to the designs of Gandon in the late eighteenth century, to the east of the present Matt Talbot Bridge. The Custom House shown on Rocque's map was one designed by Thomas Burgh at the beginning of the eighteenth century, some eighty years earlier. Facing directly onto the river with a large quay for loading and offloading ships, Burgh's building was arcaded, as were many such public buildings. Some suggestion of this ground-floor arcade is given by Rocque by means of the heavy square dots on the north (river) side of the building. A shaded area directly behind these dots was Rocque's graphic code for a covered outdoor space, known in architectural terms as a *loggia*.

There are also two more ranges of dots to the rear or Essex Street side of the building. On the eastern side of the grand entrance to the quay from Essex Street, however, is a robust line of slightly squared dots, albeit less heavy than those that indicated the piers to the front of the Custom House. There is also a shaded zone behind these suggesting a covered walkway of some sort. Comparisons with the image of a shoe boy crying his trade at the Essex Street entrance to the Custom House (Fig. 15, right), in a recently rediscovered volume of manuscript drawings made by Hugh Douglas Hamilton only four years after Rocque's map was published (1760), show that the dots in this location, set in front of a row of dwelling houses, in fact signified a colonnaded walkway, which contemporary newspaper and other sources record as the 'piazzas'. The word 'piazza' in its singular form usually refers to large open spaces. Similar arcaded walkways surrounding Inigo Jones's Covent Garden would come to be known as 'piazzas' and so the corrupt form of the word, meaning covered, colonnaded or arcaded spaces, came into general use in the late seventeenth century and eighteenth century in Britain and in Ireland. The account of a trip made to Dublin in the 1680s by Thomas Denton suggests that the 'cloisters', as he referred to them, were likely to have been first established in the 1670s, perhaps under the direction of the earl of Essex, who gave his name to the district. A shopping street of some considerable status originally, it was known in particular for its hosiery shops. The pair of feet (for stockings), shown on the shop sign in Hamilton's drawing, is a visual confirmation of this aspect of the area's commercial profile.

Fig. 15: A shoeboy at Custom House Gate, 1760, by Hugh Douglas Hamilton (Private collection).

12. ESSEX STREET PIAZZAS

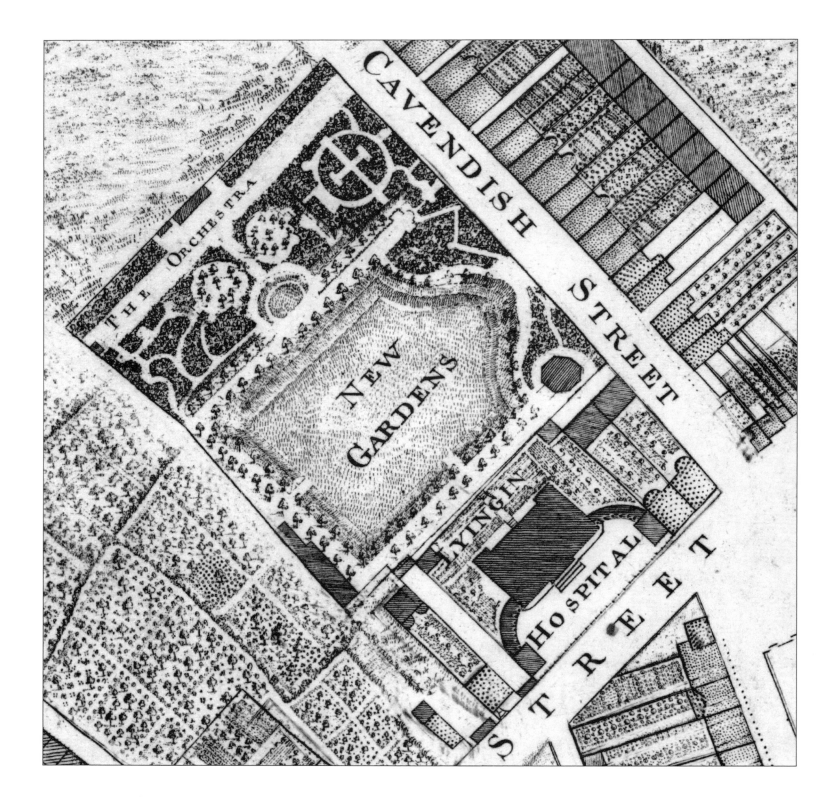

At the north end of Sackville Street (see **14**), at its junction with Great Britain Street (Parnell Street), is located one of the most extraordinary institutional buildings created in eighteenth-century Dublin. This was the Lying-in Hospital (Fig. 16), or the Rotunda, as it came to be known when the round assembly room was added in 1764. This palatial house, with its extensive pleasure gardens at the back, was the great Bartholomew Mosse's maternity hospital for poor expectant mothers. Mosse had built an earlier much smaller hospital at George's Lane (South Great George's Street) in 1745. This was the earliest purpose-built maternity hospital in these islands and had encouraged the creation of a spate of other foundations of this kind in London and elsewhere. Mosse's great idea was to finance the construction of his new larger hospital by creating an extensive pleasure garden, on the model of the Vauxhall and Ranelagh gardens in London, on a sun-washed south-facing slope on the extreme northern edge of the city.

In 1748 Mosse took a lease on a four-acre site north of Luke Gardiner's newly laid out Sackville Mall. Straight away, work on the gardens began under the supervision of Robert Stevenson. Six hundred elm trees alone were planted that year. The gardens were opened to the public in 1749 and, from the funds generated, a new building designed by Richard Castle was begun in July 1751. Castle died the same year and the work on the hospital, which was completed two years after Rocque's map was published, was executed under the supervision of John Ensor. This grand neo-Palladian granite-faced house consisted of a central block with four colonnaded quadrants (those at the back of the building were added after Rocque's map had been published). The rear façade resembled Castle's earlier Kildare House (Leinster House) (see **21**), and the urban setting to the front and the landscaped gardens to the rear also remind us of its south-side cousin. The gardens consisted of a complicated assemblage of geometrical conceits: an exedra or orchestra on the northern terrace with a wilderness to the west and a more geometrically controlled circular walk on the east. An octagonal bandstand was erected at the south-east corner. As well as the wards for expectant mothers, the hospital also contained a magnificent two-storey chapel decorated in rococo by Bartholomew Cramillion, where oratorios and charity sermons could be heard, and a great deal of extra cash was generated to maintain the institution.

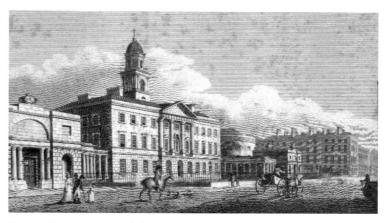

Fig. 16: Lying-in Hospital, from John Warburton *et al.*, *History of the city of Dublin* (1818).

13. LYING-IN HOSPITAL (ROTUNDA) AND GARDENS

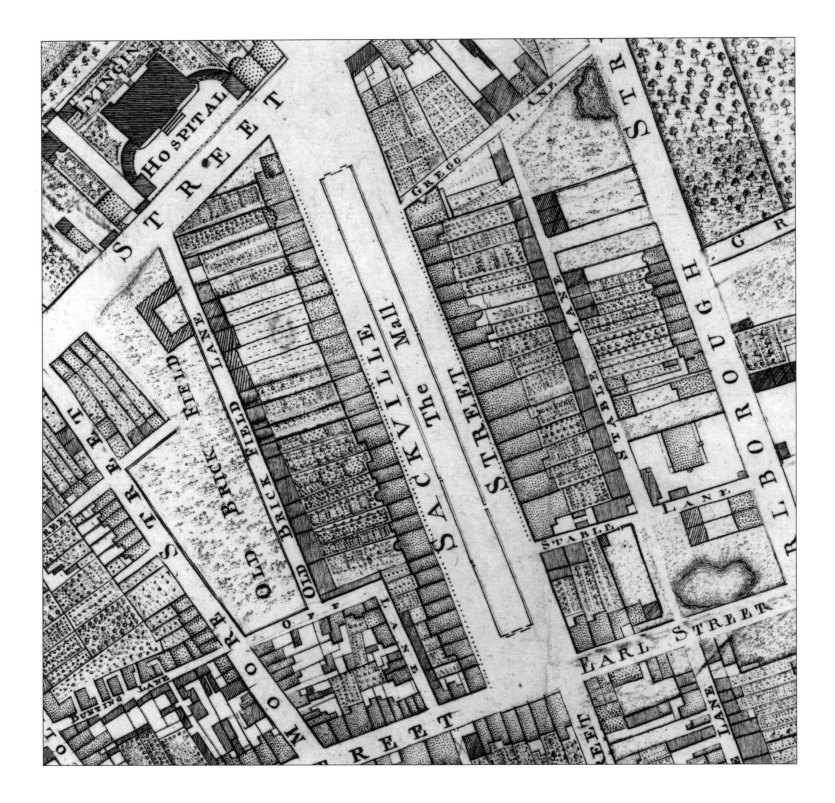

At 150 feet wide, including a 50-foot wide central enclosure or mall, Sackville Street (O'Connell Street N.) was the broadest thoroughfare in Dublin as depicted by Rocque in 1756. It ran northwards from the intersecting Henry Street to the new Lying-in Hospital (see **13**) on Great Britain Street (Parnell Street). Originally the upper section of a street opened up as Drogheda Street under the patronage of Henry Moore, the earl of Drogheda, around 1714, Sackville Street was developed in the 1750s by Luke Gardiner as the centrepiece of his urban estate. Drogheda Street (running south of the area illustrated) as constituted in 1756 was the southern or lower portion of Moore's original creation, running southwards as far as the intersecting Abbey Street. Not until the end of the eighteenth century was Sackville Street extended to the river, Drogheda Street becoming Lower Sackville Street with Gardiner's Mall, as it was known, being named Upper Sackville Street. An engraving made a few years before Rocque's map shows the street and mall fronted by large four-storeyed houses of varying widths and heights, with elegantly dressed figures promenading in the lamp-lined central enclosure or strolling along the roadways and pathways to the east and west of the street (Fig. 17, below).

The earliest states (i.e. altered variations to the first edition) of Rocque's 1756 map show Sackville Street — which had been begun in the spring of 1750 — in a state of incomplete development. The terrace of houses on the western side of the street is interrupted towards the centre by a large sandpit. Between the stable lane of this terrace and the partially complete Moore Street was located the Old Brick Field, in which place, no doubt, many of the bricks that were used in the construction of the new houses were manufactured. Houses on this side included a pair at the northern end developed by Gardiner's close associate, Nathaniel Clements, who lived here from 1753 until his death in 1775. Close by was a house built in 1752 for the physician Robert Robinson, thought to have been designed by Richard Castle, the architect of the nearby Lying-in Hospital (see **13**). This house (No. 42) — now partly incorporated into the adjacent Royal Dublin Hotel — is the only building from Gardiner's development to survive the otherwise complete destruction of the street during the Rising of 1916, and the civil war of 1922.

Rocque's map, and Tudor's *c.* 1750 view, show a wide elongated piazza rather than the highway the street has since become. Space at the centre for games and promenading was fenced off, while a clear delineation by means of bollards (a line of dots on Rocque's map) was made between the footpath and the street. The houses on the western side of Sackville Street are now shown as a complete terrace. There had previously been a gap in this terrace but in 1769 George Darley, stone cutter, built a row of five houses to complete it. That this gap is shown filled on the map state illustrated in this book indicates that this version had been revised as late as 1769 or soon afterwards. The first full new edition of the map revised by Bernard Scalé was published by Robert Sayer in 1773.

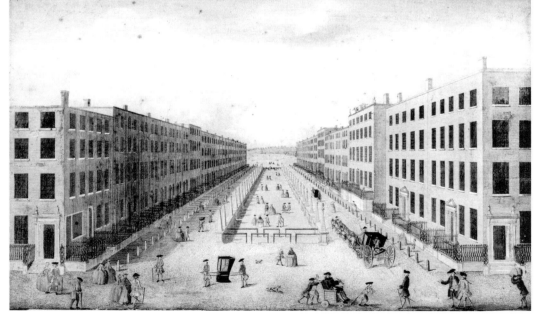

Fig. 17: Sackville Street and Gardiner's Mall, *c.* 1750, by Joseph Tudor (National Gallery of Ireland).

 14. SACKVILLE STREET: THE MALL

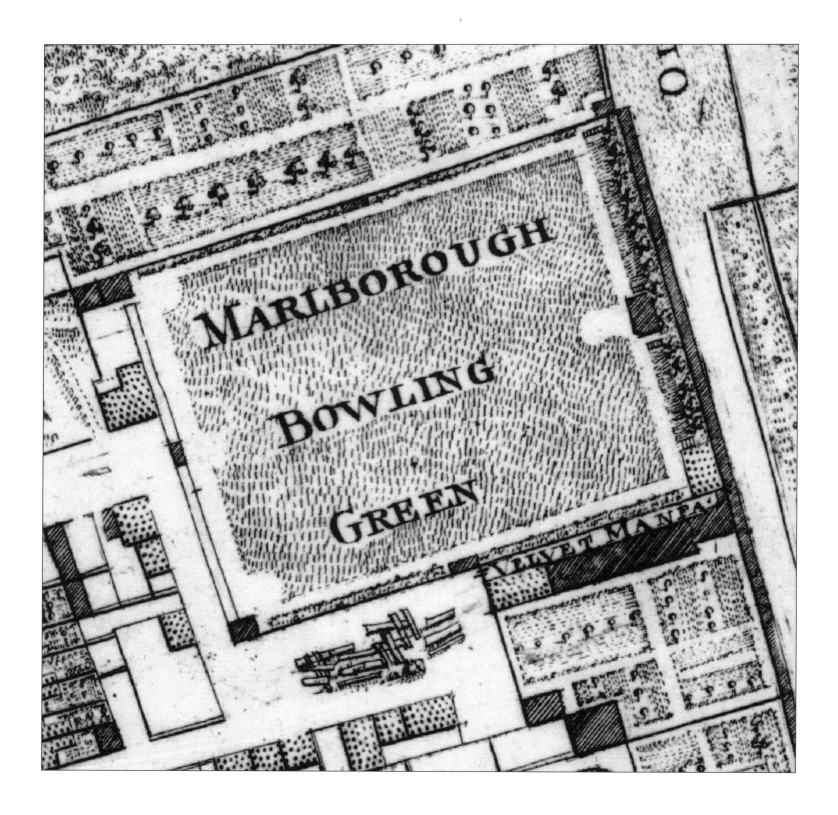

arlborough Bowling Green appears on Rocque's *Exact survey* as a nearly square piece of ground to the east of Great Marlborough Street and immediately to the west of the Old Rope Walk. Although in 1756 it was on the perimeter of urban settlement, the green was a focus of fashionable assembly to judge by the evidence of an illustration in *Hibernian Magazine* in 1790 entitled '"Taste, à-la-mode, 1745": Marlborough Bowling Green' (Fig. 18). Pictured therein is a score of elegantly attired men and women promenading in a sylvan setting, with lines of box trees receding into the distance.

The 'Taste à la mode' image of Marlborough Green was a caricature depicting the green at a date some forty-five years before its publication. Nevertheless it gives us some clues as to the nature of the space depicted by Rocque. Stippled strips to the north, east and south of the lawn on the map no doubt represent the topiary 'walls' of this outdoor assembly room, while steps on either side of a possible clubhouse on the east side suggest that the bowling lawn itself was sunk below the surrounding ground level, which would have allowed for better views of the game.

While there is no evidence in the picture of the activity of bowling, to judge by its name the green was one of a number of such sporting venues in eighteenth-century Dublin that catered for the new culture of leisure. Established in 1733, the Marlborough Bowling Green took its place alongside similar facilities in Oxmantown (see **3**), Dawson Street (behind the Mansion House, see **21**), the City Bason (see **36**) and the new pleasure gardens attached to Dr Mosse's hospital at the top of Sackville Street (see **13**). As well as affording opportunities for sporting recreation and promenading, the new 'landscapes of pleasure' provided locations for benefit concerts for city charities and state celebrations, as on the occasion of the peace of Aix-la-Chapelle in 1749 when Handel's *Music for the royal fireworks* was performed at Marlborough Green.

The green may not have survived in its 1756 form for many years thereafter. Quite apart from competition from the nearby gardens of the Rotunda, the district to the south and east of Great Marlborough Street was characterised by a number of industrial concerns (see **16**) — note the timber yard and the velvet manufactory directly to the south — and plans for the area seemed to rule out elite residential suburban development east of the Gardiner estate. In 1761, as a result of a duel, the earl of Westmeath's son was killed there, adversely affecting the popularity of the venue.

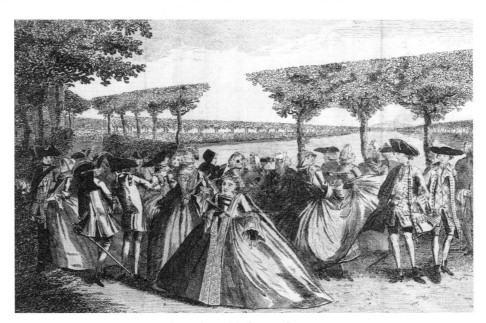

Fig. 18: 'Taste, à-la-mode, 1745', from *Hibernian Magazine*, 1790.

 15. MARLBOROUGH BOWLING GREEN

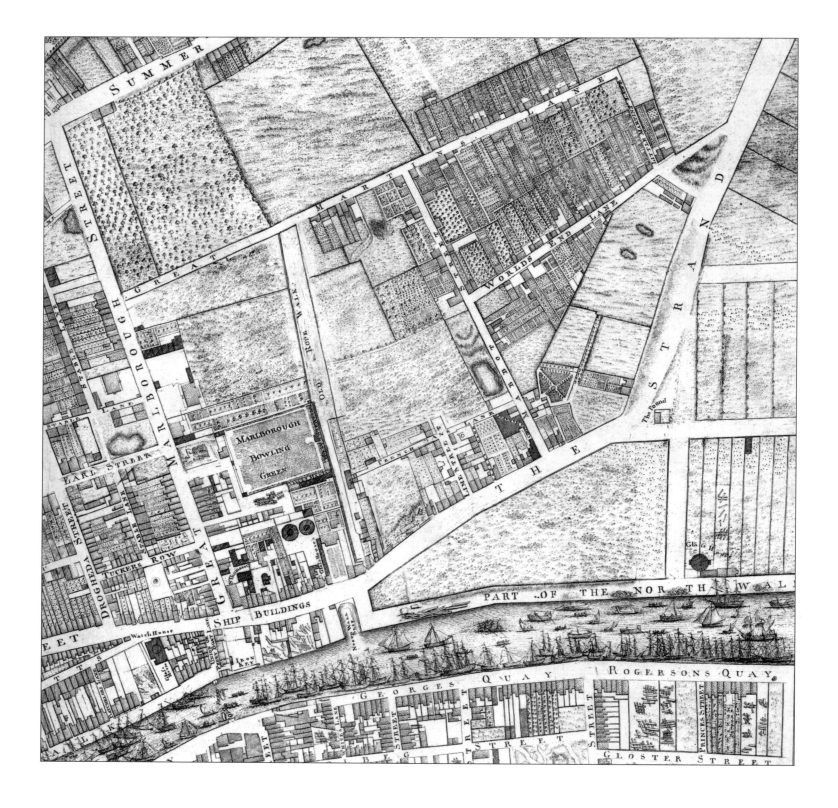

The district bounded by Great Marlborough Street and Union or Ferry Boat Lane to the west, Great Martins Lane (Railway Street) to the north and Mabbot Street (James Joyce Street/Gloucester Place) to the east, and taking in the newly reclaimed land behind the North Wall, appears to lack a social or economic identity in Rocque's depiction of it. Although proximate to the elegant Gardiner suburb to the west and north, and containing evidence of much industrial activity, there is little or no substantial residency shown and the future of this quarter could be scarcely divined from the empirical evidence of the map. For all that, there are suggestive pointers in 1756 to the way in which the north-eastern inner city developed.

The vast bulk of the area in question was to the north of The Strand (Beresford Place/Amiens Street), with little development noticeable on the reclaimed land behind the North Wall (Custom House Quay). This latter terrain is marked out according to the lotts appointed earlier in the century, but apart from the pound and a riverside glass house south of The Strand, no substantial building has taken place thereon. Owing no doubt to the protection from the tides offered by the reclamation of land, a pool and mill pond shown to the east of Mabbot Street on Phillips's map of 1685 have virtually disappeared.

Although the stretch of quayside between Bachelors Walk and the North Wall is incomplete, Eden Quay not being finished until the early nineteenth century, the evidence from Rocque suggests a busy maritime enterprise. Iron Quay fronted the river for 30 m and the street immediately to the north of that riverside block was called Ship Buildings. Taken together with the large timber yards along the river and the nearby 360 m Old Rope Walk, these features indicate a ship-repairing or ship-building industry along that stretch of the Liffey. Certainly the former Mourney's or Marney's Dock, shown as North Wall Slip on Rocque, had been used for the repairing and building of ships in the early eighteenth century.

Among the other manufactories in this quarter in 1756 were a number of glass houses, including two east of Great Marlborough Street, one west of Union or Ferry Boat Lane, and one farther east on the North Wall (GH). In addition, a velvet manufactory was located to the south of Marlborough Bowling Green, on the site of another glass house, and there was a china manufactory on the west side of Mabbot Street at its junction with The Strand. Associated with a laneway south of and parallel to the bowling green, named as Potter's

Alley on a Wide Streets Commissioners' map of 1747 (but unnamed on Rocque), were a number of commercial enterprises, including Deane and Company, Deane Barber and Company and Williams and Company (Fig. 19, below).

The economic and social character of this industrial quarter in 1756 was reflected in its later development. South of The Strand, the reclaimed land was chosen as the site for the new Custom House of the 1780s, and this major development set the seal on the dockland nature of the North Wall in the nineteenth century. Indeed its hinterland, comprising the reclaimed lotts bounded by The Strand and East Wall, was slow to develop, but was characterised by industrial activity and artisanal housing. And the area north of The Strand with its manufactories and industries remained largely outside the fashionable Gardiner estate, with perhaps the exception of the former Old Rope Walk, the site of which provided the line of the family's eponymous street. The city council had grandiose plans for a major urban extension on the north side, based on the lotts and stretching to Clontarf, but little or none of this scheme was accomplished.

Fig. 19: Lower Abbey Street area, 1747 (Dublin City Library and Archive, WSC maps 219).

16. NORTH-EAST INDUSTRIAL QUARTER

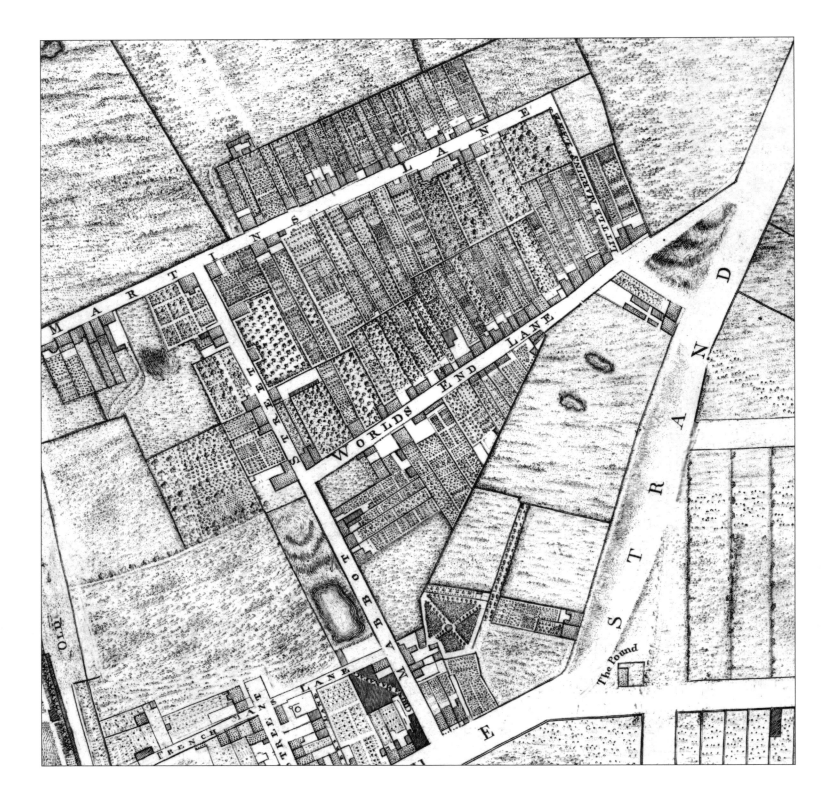

An interesting and generally underexplored part of Rocque's map is the area around Worlds End Lane (Foley Street). It would seem that its then edge-of-city location might have suggested its name. More often referred to in contemporary newspapers simply as World's End, it seems that this city district — close to the junction of the present Store Street and Talbot Street, north of Busáras — lived under this ignominious title during the early and mid-eighteenth century, before it came to be extensively developed when Gandon's new Custom House was built in the 1780s. Rocque's graphic record of the area suggests intensive market gardening that we associate in our own time with north county Dublin, the location of the present 'edge-of-city'. There were also one or two celebrated small industrial concerns at the eastern border of the 'north-east industrial quarter' (see **16**) that were identified contemporaneously as at World's End, as we shall see.

Generally Rocque did not give a key to the landscape symbols he used on his maps — one exception being a short 'Explanation to the plan' at the bottom of the great sixteen-sheet *London and ten miles around plan* of 1746. Nevertheless most of his marks can be intuitively interpreted based on their illusionistic quality. These quasi-pictorial symbols contrast with the strictly planimetric depictions of the built city and are a very pleasurable foil to the sometimes relentless two-dimensionality of the built-up areas. There are clues to interpreting the rich vegetated area depicted in a triangular block between Great Martins Lane (Railway Street), Mabbot Street (James Joyce Street/Gloucester Place) and Worlds End Lane. While there is a large number of long rectangular plots, many of them are cultivated without having dwelling houses on them. This evokes the tenement garden allotments common in more recent times. The gardens were planted intensively with combinations of fruit trees and rows of veg-

etables in a patchwork of parallel drills. It seems reasonable to conclude that the properties had been laid out in a way that facilitated future house development, but were finding profitable use in the meantime as market gardens. To the north-west of the city, taking up more than half of the first sheet of the map, was a very large agricultural area. The markings there, however, are much less intensively spread, suggesting a difference in land use and cultivation. Other examples of market gardening areas in the city, similar to that in Worlds End, may be seen on both sides of Summer Hill, on the east side of the as yet undeveloped Dominick Street, and on the east of Monks's Walk, St Stephen's Green (see **23**).

There seem to be relatively few, if any, contemporary references to this district as one of market gardens, so Rocque's record is all the more important for that. The suburb was noted in the middle of the eighteenth century, however, for at least two well-regarded craft industries. Perhaps the best known was the delftware manufactory of Worlds End, associated from the 1750s with Henry Delamain but in existence from the 1730s when the White Pothouse, as it was then known, was run by John Chambers. The earthenware factory can be identified on Rocque's map as the structure at the junction of Mabbot Street and The Strand (Beresford Place/Amiens Street), labelled 'China Manafac'. Delamain was the winner of a number of premia from the Dublin Society, whose members were particularly impressed by the fact that he used Irish clays burnt over Irish coals in the manufacture of his blue and white enamel ware. John van Beaver, the tapestry maker, also lived at Worlds End. Responsible for the tapestries depicting the battle of the Boyne and the siege of Derry, which hung in the House of Lords in the Parliament House, he was also a frequent Dublin Society premium winner.

17 . WORLDS END LANE

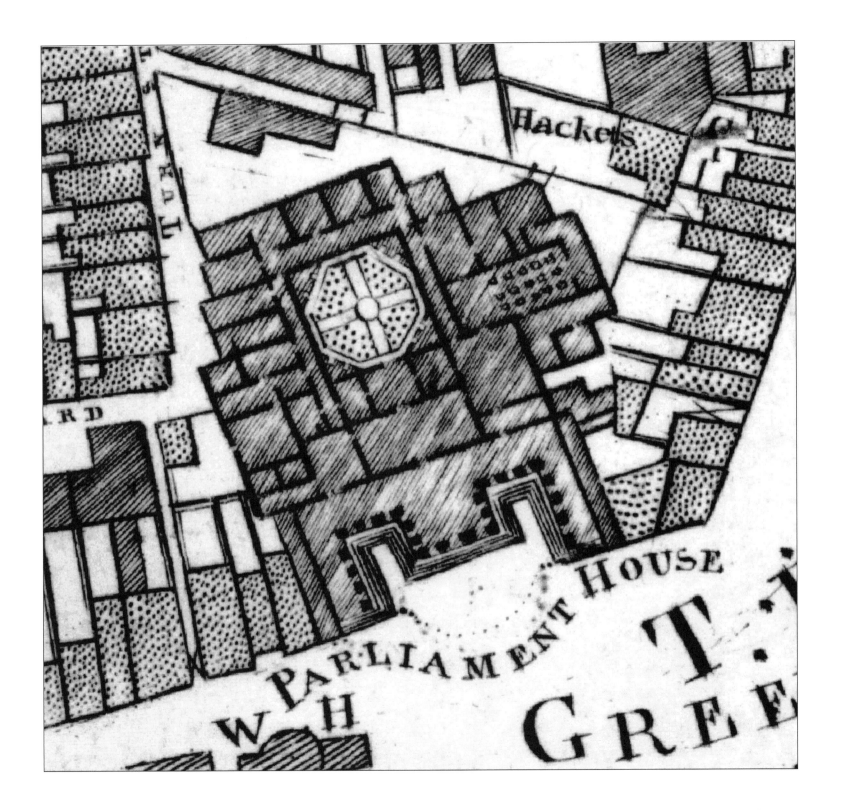

Hackets

RD

PARLIAMENT HOUSE

W H

PARLIAMENT

T.

GREE

The Parliament House (Bank of Ireland) as shown on Rocque's map represents the building designed by Edward Lovett Pearce in the late 1720s and executed from 1728 to 1739 (Fig. 20, below). The north side of College Green had been the location for the lords and commons of the Irish parliament since 1661. These had been held in the cramped and eventually dangerously decrepit Chichester House, itself built on the grounds of the former Carey's Hospital built in *c.* 1603, but never used for that purpose. College Green in turn had been a place of assembly as early as Viking times. Formerly known as Hoggen Green, the area comprised a common, and the ridge to the south (close to the present Suffolk Street) was the location of the Thingmote, the Norse place of government. Only a small portion of this former common survives at College Green, although the wide sweep of carriageway still retains great potential as a place of public gathering.

Pearce's Parliament House is built on an irregular plan. The great set-piece Palladian colonnade to the front bears little relationship to the building behind, but addresses itself directly to College Green instead and is separated from it by a convex series of bollards, no doubt linked with chains, whose shape is still retained in the present perimeter of the site. Inside the building, the plan is centred on the octagonal House of Commons, with a vaulted corridor on three sides. This was accessed from the main entrance via the Court of Requests and a smaller ante-chamber. The commons chamber was badly damaged by a fire in 1792 and swept away completely in the conversion works of the early nineteenth century. To the east is the chamber of the House of Lords, missing its apse in Rocque's depiction. Rocque also miscalculates the exact form of the central portico, suggesting that it was four columns in depth instead of two — a mistake hard to explain as the building was visible from the street then as it is easily accessed now.

Pearce's building was extended to the east and the west in the 1780s by James Gandon: a new entrance front to the House of Commons was inserted in Foster Place, a grand portico was added as entrance to the House of Lords on the east side (facing into the present Pearse Street), and these were connected to the main entrance on College Green by elegant curving screen walls. Following the Act of Union in 1800, the parliament building was sold to the Bank of Ireland, which operates still from this location.

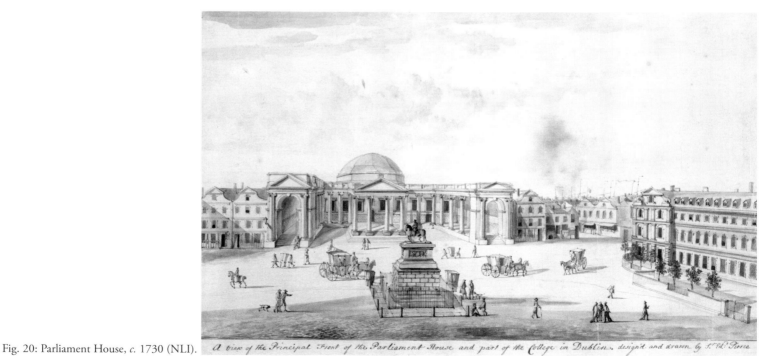

Fig. 20: Parliament House, *c.* 1730 (NLI).

 18. PARLIAMENT HOUSE

Trinity College was founded in 1592 on the grounds of the former Augustinian priory of All Saints. By the middle of the eighteenth century it comprised an extended complex of college buildings and parkland enclosed and insulated from the commercial and residential city. With the Parliament House (see **18**) and the civic space of College Green, its western entrance front provided a counterbalance to the medieval city on the opposite end of Dame Street, which at this time was still the principal thoroughfare of the city. The four-storey west front range was newly rebuilt when Rocque depicted its plan. Replacing buildings dating only to the 1670s and 1690s, the new entrance front was designed by Theodore Jacobsen, best known as the architect of the Foundling Hospital in London. However, works on site were supervised by local architect, Henry Darley, using plans and elevations prepared after Jacobsen's designs by Henry Keene and John Sanderson of London.

Behind this imposing front range the college was laid out in the late sixteenth century and the seventeenth century in a series of quadrangles — a standard approach to collegiate design and an inheritance from its monastic past (Fig. 21, right). These were opened out into the present enormous space only in the middle of the nineteenth century. To the south of these 'quads' was a series of gardens, one of which was arranged in geometrical parterres made up of interlocking circles. The gardens were separated from Nassau Street by a wall and some dwelling houses. To the east was College Park, whose great avenues of trees defined walkways around the perimeter. Between park and gardens was surveyor-general Thomas Burgh's Anatomy House of 1710–11. Commissioned by members of the Dublin Philosophical Society, Thomas Molyneux, professor of physic in the college, and Sir Patrick Dun, a patron of the professorship of medicine, the building housed not only a theatre for dissections, but also spaces for chemical experiments and a herbarium. Burgh's most important building in Trinity was undoubtedly the old library, also shown in plan form on Rocque's map. This colossal 27-bay edifice dwarfed the mainly seventeenth-century residential ranges into which it was set. Those to the north — the Rubrics — survive in modified form today.

Finally, an avenue of trees to the north leads to Richard Castle's temple-fronted printing house built in 1734–6. Inconsistencies between the representation of this avenue on the north-east and south-east sheets — digitally connected for this extract — show that the join

was not well managed by Rocque's engravers. Castle's dining hall and bell tower are also shown in Rocque's plan. The dining hall (labelled 'Hall') was poorly built and suffered partial collapses in 1744, 1747 and 1758, after which it was replaced by the present building executed by Hugh Darley. Castle's bell tower (immediately W. of the 'Hall') was also replaced by the present campanile, designed and built by Charles Lanyon in 1852–4.

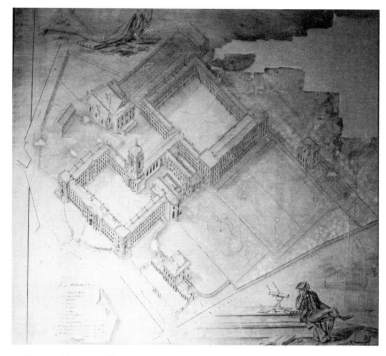

Fig. 21: Trinity College, 1790, by Samuel Byron (TCD, MS MUN/MC/9).

19. TRINITY COLLEGE

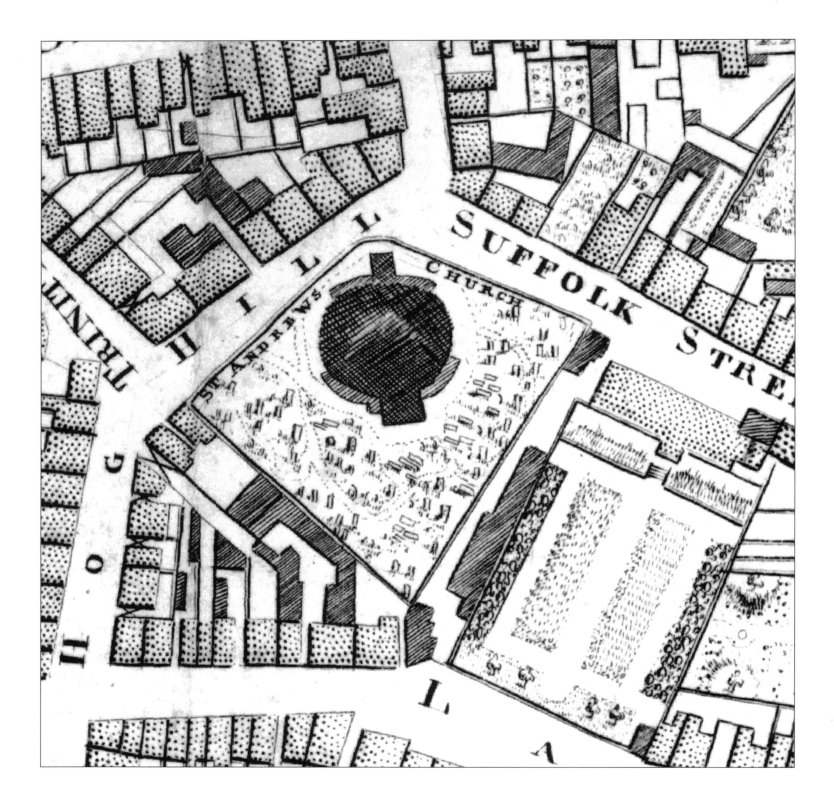

The zone around St Andrew's Church gives a fair sample of the meticulous work of Rocque's engravers coupled with the sometimes wayward recording by his surveyors on the ground. Here we see the so-called Round Church of St Andrew built by William Dodson in 1670–74. Rocque's representation of St Andrew's is not entirely correct. Dodson's church was built on an oval plan, an unusual shape for a Protestant church in these islands. It is very likely, although surprising, that Dodson's source was Sant Andrea al Quirinale, in Rome. Dedicated to the same saint, Bernini's oval church, whose short axis exaggerated the closeness of the altar to the door, was wholly unique when it was begun scarcely a decade before the Dublin church and the coincidence of their shape was hardly accidental.

Set within a diamond-shaped site, the church (Fig. 22, right) is bordered to the north by Hog Hill (St Andrew Street) and by Suffolk Street. To the south-west lies a complex of small dwelling houses and commercial premises with their related warehouses and workshops to the rear. To the south-east lies the townhouse of Robert, nineteenth earl of Kildare, built from about 1716. His son, James, was responsible for building Kildare House (Leinster House) (see **21**), from about 1744. Kildare's Suffolk Street house is shown set back from the line of the street, with stables accessed down a lane to the western side. Steps to the rear of the house suggest a terrace before a sunken garden of great size beyond it. This house is one of a number of very large houses of this type illustrated by Rocque on the map, including Speaker Conolly's townhouse on Capel Street (see **8**), Richard Boyle's early seventeenth-century Cork House on Cork Hill (see **27**) and Primate Boulter's house on the south-western corner of Henrietta Street (see **5**). Before its development in the 1670s, a mound of earth survived at what had been the site of the Viking Thingmote — the place of assembly or parliament — and before the church was built to the designs of William Dodson in the 1670s there had been a bowling green in this place.

Rocque's principal engraver on this project, his fellow Huguenot, Andrew Dury, paid exhaustive attention to certain details throughout the map. Building types were demarcated by a strict graphic code. The plans of dwelling houses were marked by stipples, stables, warehouses and workshops by a diagonal hatching, and public buildings were cross-hatched, as we can see in the representation of St Andrew's. Throughout the map, Dury has taken the extra care to delineate boundary walls with a double contour line.

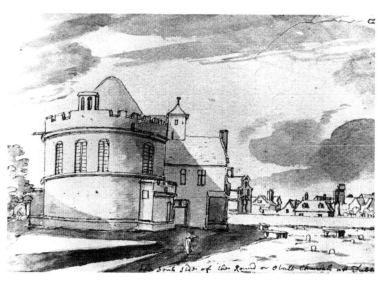

Fig. 22: St Andrew's Church, 1698, by Francis Place (Irish Architectural Archive).

20. ST ANDREW'S CHURCH

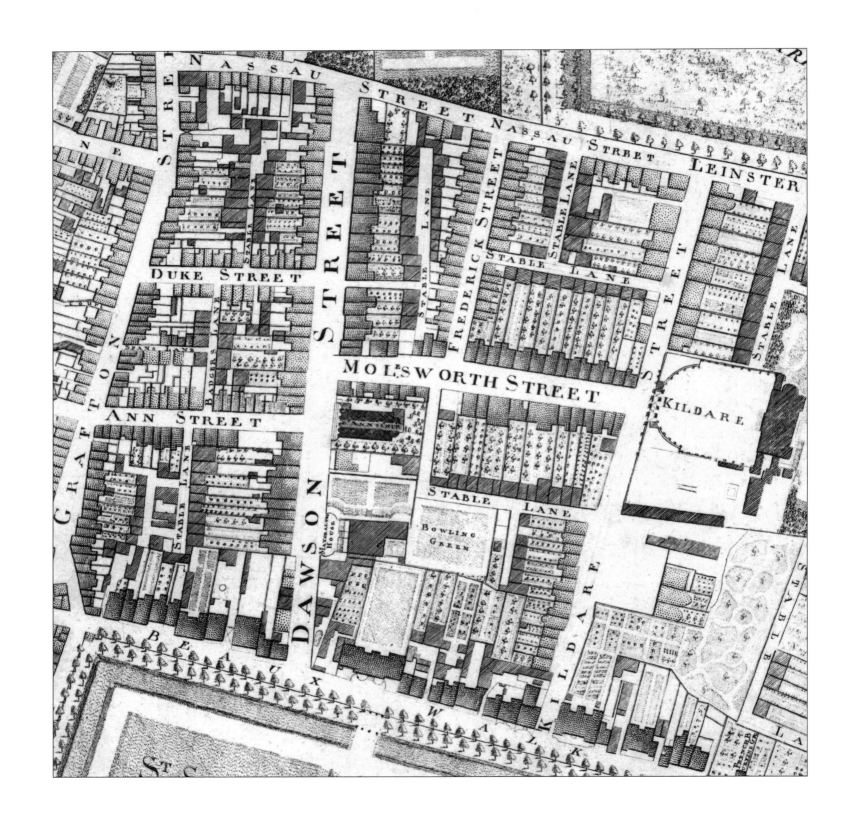

In the *Exact survey*, the city block framed by Dawson, Molesworth and Kildare Streets and the north side of St Stephen's Green contained the Mansion House, St Ann's Church and a bowling green, attesting to the upmarket and settled nature of this recently completed development.

Sir Joshua Dawson had opened out his street with its radials, Duke and Ann Street, in the early eighteenth century and had built himself a mansion on the east side of the new boulevard in 1710. At that time, the civic corporation was seeking a suitable house or site for a residence for the lord mayor. A number of possibilities were canvassed, including Lazers Hill (Townsend Street), Aungier Street and St Stephen's Green, before Dawson's offer to sell his new mansion to the city for £3,500, at below the cost price, was accepted. He also agreed to build a new room to the northeast. In 1715 the building was turned over to the corporation as the residence for the mayors.

The Mansion House, as it came to be known, was constructed on the east side of Dawson Street and is a seven-bay, two-storey-over-basement house that was brick built (Fig. 23, top right). It contained a large drawing-room and dining-room and an impressive entrance hall and staircase, as well as the newly-constructed room, wainscoted in oak. The Dublin mayors had their own official residence at least twenty years before their London counterparts. In the later eighteenth century the building was enlarged and enhanced, and additions and refurbishments have continued in the centuries down to the present.

The construction of St Ann's Church (1720) to the north attested to the settlement of a prosperous community in the new neighbourhood, no doubt attracted in part by the presence of the mayoral residence. Ann Street was an axis linking Dawson to Grafton Street, with the church closing the vista. The bowling green to the rear of the Mansion House catered for a leisured class, with opportunities for promenading and disporting. Robert Molesworth's eponymous street was set perpendicular to Dawson Street and was eventually closed by the vista of Kildare House (Fig. 24, above right), fronting the street to which the proprietorial family gave their name.

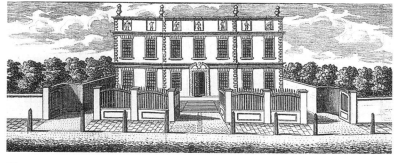

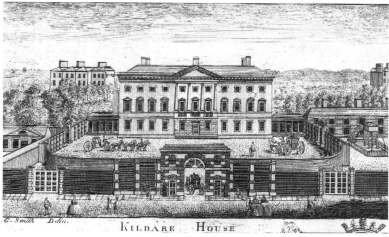

▲▲ Fig. 23: Lord mayor's house, from Charles Brooking, *A map of the city and suburbs of Dublin* (1728).

▲ Fig. 24: Kildare House, from John Rocque, *Survey of the city, harbour, bay and environs of Dublin* (1757).

By the time of Rocque's map, the area to the east of Grafton Street had become one of the most fashionable in the city, with its stately residences, elegant parish church and leisure facilities. At its heart, the Mansion House ensured a fittingly stylish residence for the lord mayors of the thriving city.

 # 21. MANSION HOUSE, DAWSON STREET AND MOLESWORTH STREET

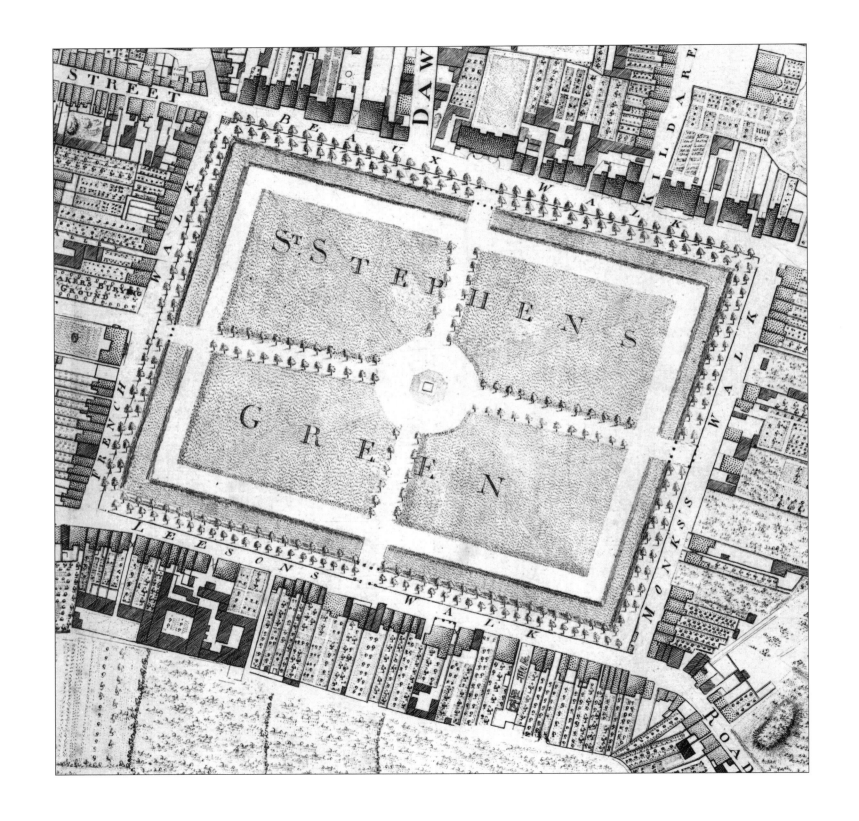

St Stephen's Green, one of the medieval commons of Dublin, was the location for a major initiative in the early modern planning of the city. The civic assembly in 1663 decided to set the green, part of the 'waste ground that added nothing at all to pleasure or profit', to fee farm or rent on long lease in order to alleviate the penury and 'exhaustion' of the municipality. A committee 'for the advance of the city revenue' surveyed the green and in the following year the process of letting was under way, plots being divided among the aspirant developers by lot. As well as determining the size of the lots (60 feet as frontage and from 80 feet to 352 feet in depth) and the rental (from 1d per square foot for the north side to a ½d for the south), the city council stipulated the dimensions and materials of houses that lessees were to build. Provision was also made for the walling and paving of the central green area, the eventual residents paying for its accomplishment and agreeing to plant six sycamore trees each near the wall. The square was constructed over the next several decades, the houses being built piecemeal by resident lessees or by speculators who sometimes redeveloped on their plots as leases were renewed. The eastern and southern sides of the green were de-

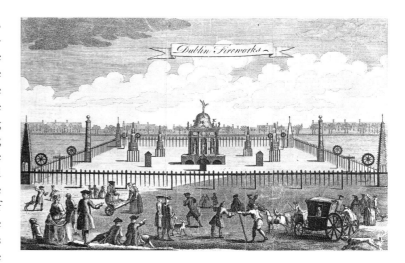

veloped much more slowly than the western and northern, which were contiguous to existing buildings.

By the late 1720s a fine square had been created with houses of varying width and style fronting the most pleasant and fashionable recreational park in the city. As depicted by Rocque, three sides of the green, named Beaux Walk, French Walk and Leeson's Walk, were completely flanked by residences, though the fourth, the east side or Monks's Walk, still had some vacant sites. Among the grand palazzi on the north side of the square were the residences of Dean Harman of Waterford (now the St Stephen's Green Club) and of Lord Milltown (now the University and Kildare Street Club). Both were noted for the elegance of their architectural design and interior decoration. The central park was laid out with tree-lined walks converging on an equestrian statue of George II. By the 1750s St Stephen's Green was at the hub of polite recreation in Dublin, being a popular promenading ground for the *beau monde* and being compared favourably to St James's Park in London. It also had become the venue for public festivities and demonstrations on the part of all civic classes (Fig. 25, above and Fig. 26, left).

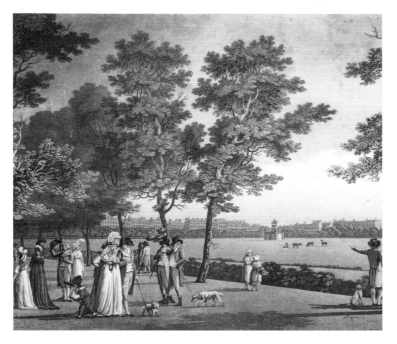

▲ Fig. 25: St Stephen's Green, 1749, by Joseph Tudor.
◀ Fig. 26: St Stephen's Green, 1796, from James Malton, *A picturesque and descriptive view of the city of Dublin …* (1792–9).

 22. ST STEPHEN'S GREEN

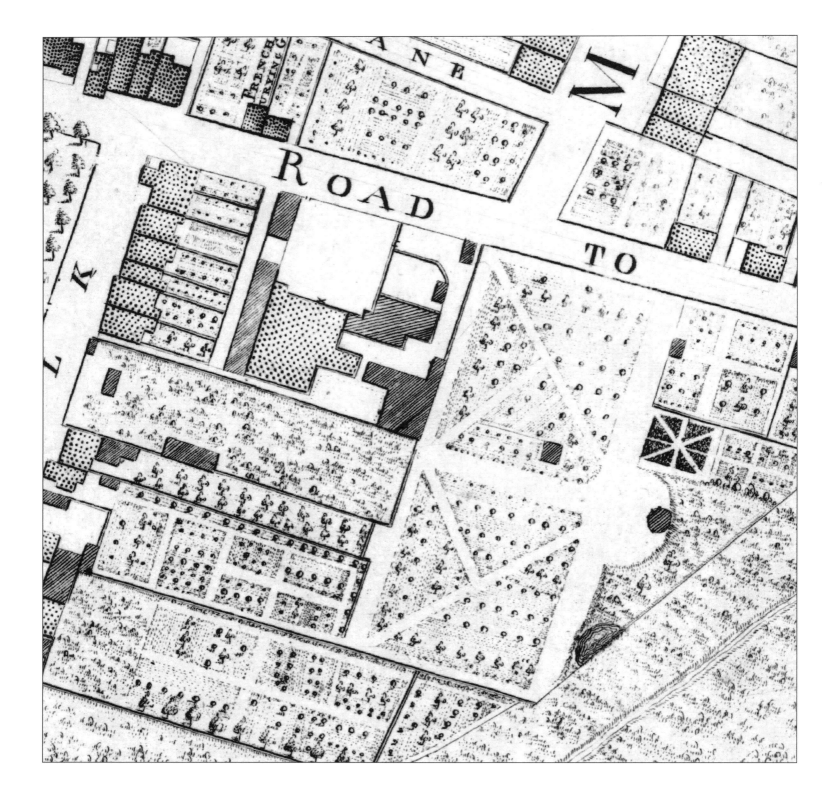

Close to the north-eastern corner of St Stephen's Green is a very carefully delineated plan on the *Exact survey* of a house and grounds that faced north onto the Road to Balls Bridge (Merrion Row), to the east of a terrace of six houses at the northern end of Monks's Walk (Stephen's Green East). This house is likely to have been the house built in the 1680s by Colonel Dillon, later the earl of Roscommon, but was afterwards Peter Landré's house. It was located directly west of his well-known fruit gardens. Landré was a Huguenot horticulturalist, who hailed from Orléans, but was based near St Stephen's Green and specialised in 'staples and rarities' such as peach, apricot, plum, pear and apple trees. His nurseries can be seen in two large square patches of cultivated land criss-crossed by diagonal paths. The house itself is nestled amongst a series of outbuildings, offices, stables and neat courtyards, somewhat in the manner of a French-style *hôtel-entre-cour-et-jardin*, except that in this case the gardens to the east were working rather than leisure gardens, at least at first. The stables and carriage house were accessed through lanes coming from Monks's Walk and from the Road to Balls Bridge. The *basse-cour* seems to be lined on three sides by bollards, as the light rows of dots there suggest.

Landré first leased a house here in 1709. He died in 1747, some years before the house and gardens were depicted by Rocque. In his will he expressed a wish to be buried in the French churchyard near St Stephen's Green — the French Burying Ground is shown across the road on Rocque, where it remains to this day. While the house was left for her lifetime to his wife, the business concern passed to his nephew, John Landré, who announced in the *Dublin Courant* in 1749 that he intended to be 'always furnished with the best assortment of seeds and fruit trees' and had 'imported a great variety of garden seeds, flowers, shrubs, peach, and cherry trees' for those gentlemen who were 'pleased to deal with him'. In the following year, however, the younger Landré decided to create a pleasure garden along the lines of those in Vauxhall and Ranelagh in London. The Spring Garden was to be opened 'on a new plan for the entertainment of the nobility and gentry of that neighbourhood'. The gardens would include 'an elegant orchestra, decorated at the back with a piece of water, in the form of a half moon', whose advantages would be both ornamental and acoustic. Also to be provided was 'a large house containing two rooms; the larger designed for dancing and retiring in the case of rain; the lesser for tea, coffee, chocolate and so on but no other liquors'. Evergreen trees were to be planted 'to afford a shade in the summer and shelter in the winter'.

Despite the fact that John Landré sold the pleasure gardens 'for building' in December 1751, Rocque's depiction of 1754–6 matches closely the earlier advertisement. A circular building — hatched diagonally, but with circular dots on the east side suggesting a colonnaded exterior — is set in a semi-circular enclosure. Perhaps the irregularly shaped building to the south-east of the house had been converted to these tea and dancing rooms. These would have given direct access from St Stephen's Green to the pleasure complex. In 1751 John Landré conveyed the house and gardens to Anthony Malone, MP, and he in turn sold his concern to Gustavus Hume in 1769. It was Hume who redeveloped the property afterwards and new terraces of houses on Hume Street and Ely Place were built in their place.

23. PETER AND JOHN LANDRÉ'S GARDEN

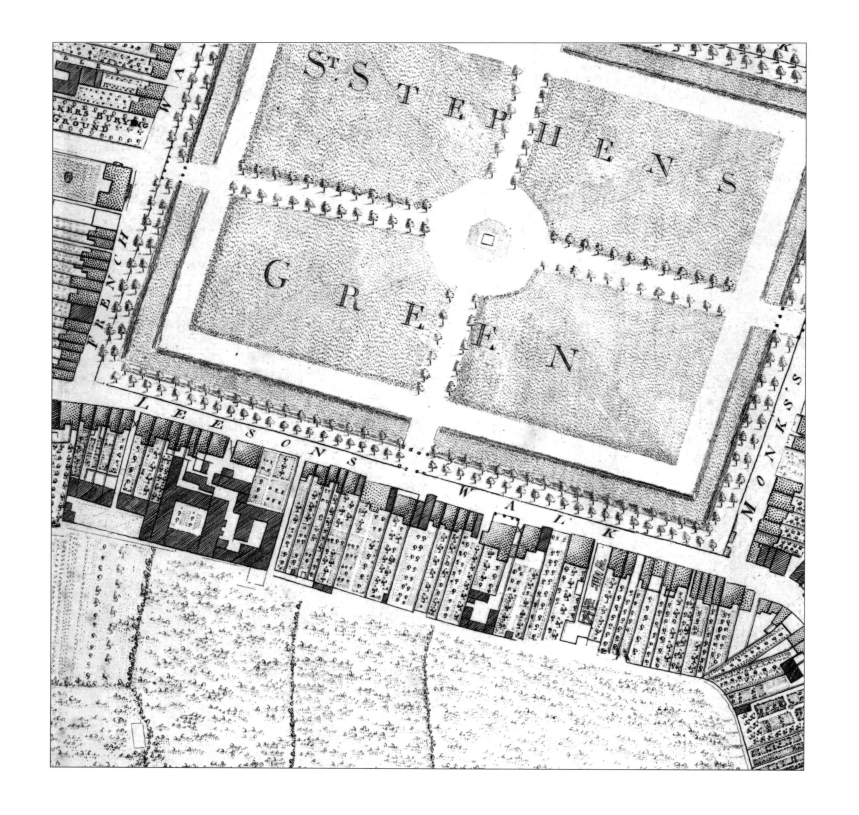

On the south side of St Stephen's Green there is a terrace of houses along what was known as Leeson's Walk, no doubt because of the location here of Joseph Leeson's large house, gardens and brewery (complex of buildings below text 'EESON' of Leeson's Walk on map extract). Leeson, first earl of Milltown, also built a palatial residence on the north side of the Green (see **22**). East of his property is a terrace of houses that includes nos 85 and 86 St Stephen's Green, i.e. the combined pair of houses that have made up Newman House since the second half of the nineteenth century (opposite the southern gate to the green on the map extract). The house on the east was built by Hugh Montgomery in 1738 and was probably designed by Richard Castle. The house on the west is said to have been built on a green-field site by Richard Chapel Whaley in 1765, despite the fact that Rocque records a building here in 1756. Besides their architectural and historical value, the whole terrace here is of particular interest on the *Exact survey* as it exposes one of a very small number of examples where Rocque's record of these buildings was critically revised by Scalé in his second edition of the map. Although the new map was engraved and published in London by Robert Sayer,

Scalé, Rocque's brother-in-law and apprentice, was responsible for resurveying Rocque's original in 1773 and a great number of the changes to the city that had taken place in that seventeen-year gap were recorded on this new edition.

While most of the amendments made by Scalé reflected material changes to the city, a small number of alterations can be interpreted as a critical revision by the younger cartographer of Rocque's original. The uneven terrace of houses between Leeson's house and what was later Newman House has been pared back in Scalé's map to form a straight façade (Fig. 27). The two diagonally shaded stable or warehouse buildings beyond them have also been evened off to match the fronts of the houses to their right. The result on Scalé's map is a façade of houses more or less in a line, except for two larger houses set back from the street. The two larger houses in question were also fixed by Scalé to present an even straight front. They are in reality flush with each other as Scalé suggested. This reworking of the record is one of a rare set of such critical changes. Others include a terrace of houses on the west side of George's Lane (South Great George's Street) and another on the east side of William Street.

Fig. 27: St Stephen's Green south, from Bernard Scalé's revision of the *Exact survey*, 1773 (Royal Irish Academy).

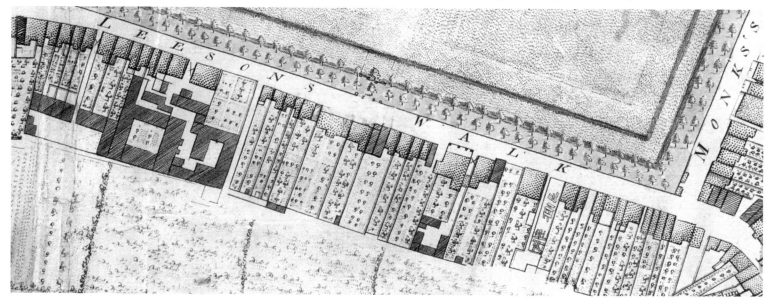

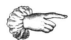 24. ST STEPHEN'S GREEN, SOUTH-SIDE TERRACE

Francis Aungier, the earl of Longford, laid out a suburb centred on the former monastic estate of Whitefriars to the south-east of the old walled city between 1660 and 1685. To accomplish his plan, Aungier acquired adjacent property, leasing land from the crown, the municipality and St Patrick's Cathedral. Some piece-meal suburban growth had taken place to the north of Aungier's estate and the family had a mansion on the site of the old monastery of Whitefriars. Aungier capitalised on the demand for high-quality housing in the Restoration era by offering commodious sites for building in a green-field area that had been preserved from industrial activity. Regularly aligned streets were laid out and opened within the precinct, the most notable being Aungier Street, at the time of its construction in 1661 the widest in the city at 70 feet. Opening out to the east and west of Aungier Street were Longford Street, Great Cuff Street and York Street, the alignment of the latter two being influenced by the plan of St Stephen's Green and its encompassing streets (see **22**, **24**). Many developers leased holdings from Aungier and proceeded to build large houses along the streets; well before the year of his death in 1700, the old monastic enclosure of Dublin represented in the line of White Friar Street and St Stephen's Street was gridded with coherently planned streets, lined with imposing mansions for an elite residential corps. The fashioning of a suburb occasioned structural changes in the parochial organisation of the district: the site of the ruinous old church of St Peter on the Mount was abandoned and built over, and a new parish church of St Peter was erected on a site donated by Aungier in 1680. On Rocque's *Exact survey* the district had been fully integrated within the urban fabric, though the distinctive ovoid shape of a putative early medieval monastic enclosure is still very evident as its perimeter.

Rocque depicts St Peter's Church (Aungier Street W.) in open ground (Fig. 28, below). One or two paths weave among some upright gravestones. To the north is the square-planned Methodist meeting house (MH), built in 1750, on White Friar Street, and further north is the 'old theatre' or Theatre Royal, built only twenty years earlier (1733) by the architect of the Parliament House, Edward Lovett Pearce. East of Aungier Street are three suggestive sounding laneways, Goat Alley, Love Lane and the probably misspelt Beaux Lane. The last was a corruption of Bow Lane, itself a shorthand for Elbow Lane, no doubt given this name because of the bent shape of the street.

Fig. 28: St Peter's Church, *c.* 1820 (National Gallery of Ireland).

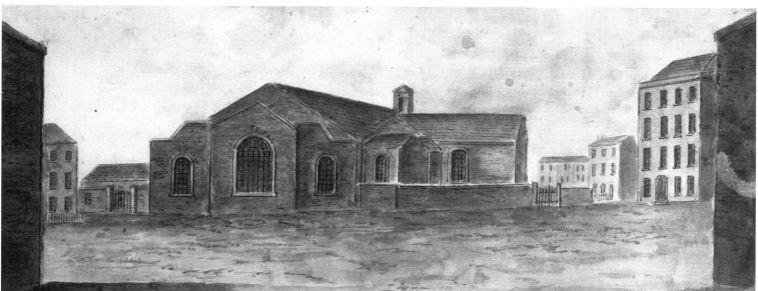

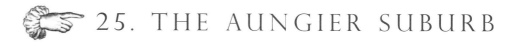 25. THE AUNGIER SUBURB

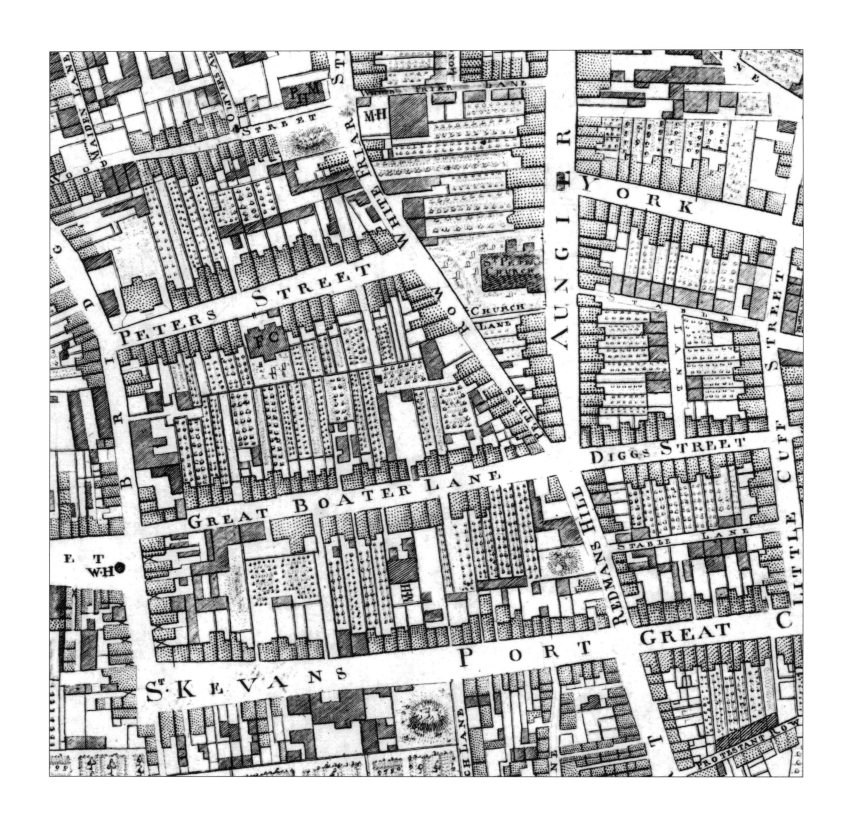

Straddling the line of White Friar Street and its southward extension of Peter's Row on Rocque's *Exact survey* are shown the meeting places of four different Protestant denominations. On opposite sides of the White Friar Street junction with Wood Street were the Methodist preaching hall (MH) to the east and the Presbyterian meeting house (PMH) to the west. South of Peters Street was located a French Huguenot church (FC), while the Moravian meeting house (MH) was to be found south of Great Boater Lane (Bishop Street). Perhaps encapsulating the religious character of this suburb was the designation of a lane to the south-east of St Kevin's Port as Protestant Row. This concentration of meeting houses reflects the growth of Protestant alternatives to the Anglican church in the eighteenth century.

This suburban area occupied the interstices between the ecclesiastical liberties of St Patrick and St Sepulchre to the west and the new Aungier suburb to the north and east (see **25**). Thus perhaps lacking a strong patronal influence on development, the quarter may have been particularly suited to the growth of individual confessional congregations, while at the same time being close enough to Dublin Castle (see **27**) as well as St Patrick's Cathedral (see **30**).

Presbyterianism had become firmly established in Dublin in the 1660s, despite the reimposition of the Act of Uniformity in 1665.

Among the meeting houses founded was the substantial one at the junction of White Friar Street and Wood Street that was built in 1667. It was the centre of an independent congregation. Just opposite it stood the Methodist preaching house, constructed about 1750. The building, which survived for at least a century and a half, had its pulpit at the west end. Members of the Methodist congregation crossed to St Patrick's Cathedral to partake of the sacrament.

Also representing the coming of the evangelical movement to Dublin and built just before Rocque's map appeared in 1756 was the Moravian meeting house on Great Boater Lane. Smaller than the Methodist building, the Moravian church, which still survives, was arranged with an eastern orientation. Finally there was the French church on Peters Street. One of four such churches in Dublin, of which two were south of the Liffey, the Peters Street church was a non-conforming one that had been consecrated in 1711. The site accommodated a burial ground for Huguenots.

Rocque's map, which gives due acknowledgement to the vibrancy of non-established Protestantism in the south-west of the city, nevertheless reflects its standing through the lack of main street frontages for the buildings. They were either slightly back or else shown to be accessible along narrow lanes.

26. A PROTESTANT SUBURB

By the time John Rocque surveyed Dublin Castle for his *Exact survey* in 1756, the buildings and grounds had undergone over seventy years of extensive, if sporadic refurbishment. In 1684 much of the old medieval castle had been destroyed in a major fire, which had almost caused a huge explosion of munitions then stored on the premises. Some previously accomplished improvements to the apartments were thus wiped out and a complete restoration was under way by 1700.

The former castle had served as a fortress and prison as well as an administrative centre, and testimony to this role is evident in the surviving Bermingham and Record Towers on the south side of the building. But the emphasis in the rebuilding programme was on providing stately premises for an expanding courtly establishment in Dublin, headed by the lord lieutenant. The Upper (or western) Yard was the focus of much of the building in the early decades of the eighteenth century. Another fire, this one in the council chamber building on Essex Street in 1711, necessitated the council's relocation to the eastern side of the Upper Yard and the state apartments, including the ballroom, were completed by the 1750s. A realignment of the main entrance was accomplished on the axis from Cork Hill and Blind Quay, and the suite of Upper Yard buildings was completed with the construction of the Bedford Tower (Fig. 29, below right).

Additional buildings gave shape to the Lower (or eastern) Yard, including the treasury and the chapel, and an entrance was forged to that space through Castle Lane. To the south of the buildings lay the gardens that were flanked by other offices and stores. The riding establishment was accommodated to the east of the Lower Yard, as were the stables.

By the 1750s, the castle was the lord lieutenant's residence, a brief period of relocation to Chapelizod being brought to an end. It was also the venue for lavish entertainments, including levees, balls and theatrical entertainments for the *beau monde*. The civilian administration was also centred here, the military establishment having been moved outside the urban core to new installations to the west in the Royal Barracks, Royal Hospital and Phoenix Park. Now at the ceremonial heart of the city, the castle, along with the new Parliament House (see **18**), bodied forth the power of the state over the lives of the citizens.

The later state of Rocque's *Exact survey* used in this book, which includes revisions on the north-eastern sheet to Sackville Street (see **14**) dating to as late as 1769–70 captures the beginnings of one of the most radical series of alterations to the fabric of the early modern city carried out by the Wide Streets Commissioners. The goal of this body, established by act of parliament in 1758, was to widen and create a more convenient avenue between the newly refurbished Essex Bridge (see **11**) and Dublin Castle, which until then could only be accessed along the constricted Crane Lane. Parliament Street, the broad unlabelled avenue running from the bridge to the castle, was completed in 1762 and a new wide square to the north of the Upper Yard were the result.

The new square involved the clearance of a complete block of houses and traces of the removed lines from Rocque's original engraving can still be discerned on this version of the map. The text 'Bedford Square' (named for John Russell, 4th duke of Bedford, lord lieutenant 1757–61) appears on two surviving states of the map, and the square itself was short-lived. It was replaced by the Royal Exchange (City Hall), built to the winning competition designs (1768–9) of Thomas Cooley. Although it took up to ten years to complete, the new building is depicted on the site of Bedford Square on the first fully revised edition of the *Exact survey* carried out by Rocque's brother-in-law, Bernard Scalé, and published in London in 1773 by Robert Sayer.

Fig. 29: Upper Castle Court, 1753, by Joseph Tudor.

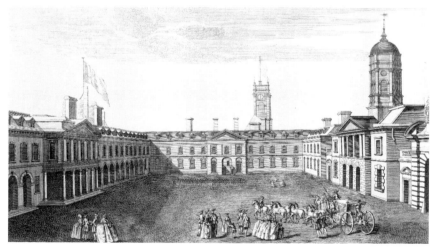

▲ Fig. 30: Christ Church Cathedral, *c.* 1739, by Jonas Blamyres.
▼ Fig. 31: Christ Church Cathedral, *c.* 1820, by George Petrie.

The depiction of Christ Church Cathedral in Rocque's *Exact survey* conveys the impression of this major ecclesiastical institution being cramped within a crowded city block. The church building itself occupies the northern side of the block along John's Lane, while to the south of the cathedral and at the centre of the site there was a small yard, which once contained the chapter house and chambers of the former monastic community. The chapter house of the cathedral had been moved to the south aisle in 1699 (Figs 30, 31, left). To the south-west of the cathedral stood the four courts of chancery, king's bench, common pleas and exchequer, built on the site of the medieval cloister, which was rented by the state from the cathedral. The rest of the Christ Church precinct was filled with a jumble of large and small premises, some of them the former residences of the cathedral dignitaries and others newly-built to house commercial ventures, such as the making of musical instruments. Just before Rocque's survey, the cathedral itself had been 'repaired and beautified' in 1754, while the east gateway from Fishamble Street had been demolished the previous year. The eastern and western entrances are indicated by Rocque.

Rocque's depiction of this major public building seems somewhat clumsy. We do not need to compare it to other contemporary plans of the cathedral to see, for example, that the transepts of the church are located at different places along the nave, i.e. they are not opposite each other, as they are in nearly all churches, and in the surviving cathedral itself. This contrasts with Rocque's much more convincing treatment of the plan of St Patrick's Cathedral (see **30**). Closely ranged about Christ Church are four other churches, representing some of the intimately clustered parishes within the walls of the medieval city. From north of the cathedral, and in clockwise direction, are depicted the churches of St John, St Werburgh, St Nicholas Within (the walls), and St Michael. Of these, only St Werburgh's remains fully intact. Built by Sir Thomas Burgh, its rough-hewn granite front (probably lime-rendered when first built) is depicted in elevation in Brooking's map of 1728. St Michael's and St John's were later amalgamated into a single parish, although the tower of the former was incorporated into the Synod Hall, which is now Dublinia and is linked to the heavily restored Christ Church by an elegant enclosed bridge (designed by G.E. Street) over Wine Tavern Street. The entrance façade and the shell of St Nicholas still stand at the head of Nicholas Street on the brow of the hill that was the location of the old city wall.

 28. CHRIST CHURCH CATHEDRAL

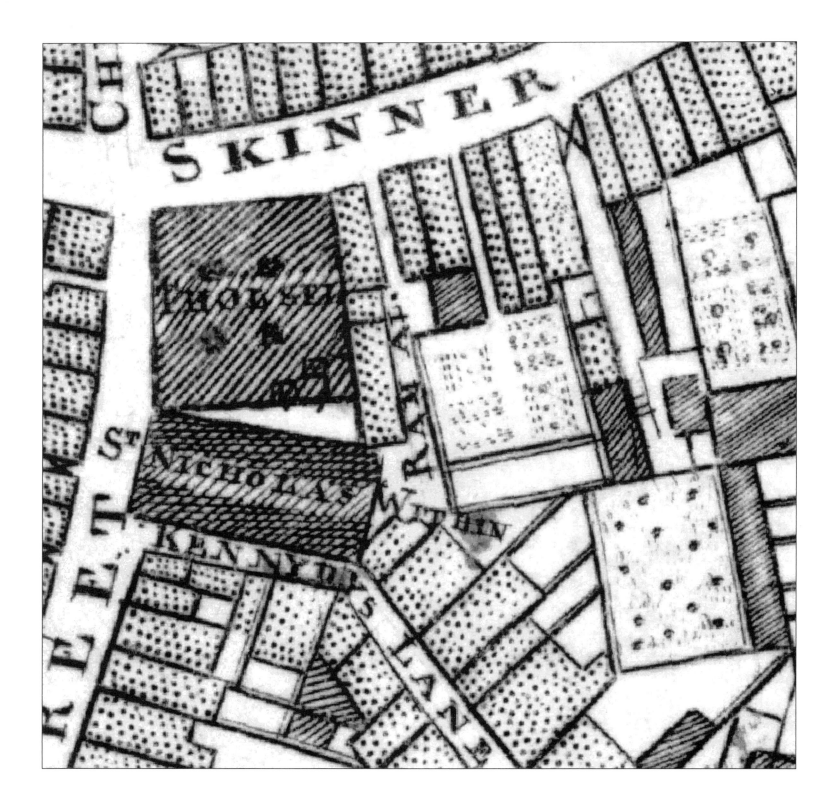

The Tholsel, headquarters of Dublin civic government since the middle ages, occupied the block at the corner of Nicholas Street and Skinner Row (Christchurch Place), which it fronted. The building had been completely rebuilt between 1676 and 1685 under the supervision of Thomas Graves on the existing site, though enlarged by adjacent land. Whereas the old building apparently had been a plain edifice, the refurbished one, as first depicted by Thomas Dineley, was ornate with pillars, arcades and niches for statues, all topped by an elaborate lantern containing a clock (Fig. 32, below). The niches were filled by statues of Charles I and Charles II, though other scholars have claimed that James II was the subject of the statue mooted to be that of the latter's father. Charles Brooking's vignette of 1728 depicted the finished building (Fig. 33, right), but by the time of Malton's painting of 1793 the elaborate upper structure had been removed (Fig. 34, below). The new building contained the council room of the guild of merchants where the city

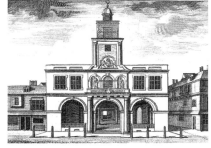

council met, a great room for city entertainments and various offices, including a record room. It also incorporated on its arcaded ground floor the merchants' exchange that had previously been housed in the grounds of Cork House on Cork Hill. Also at ground level was the recorder's court or sessions house. Rocque's depiction is of a plain square plot, with symbols indicating the arcaded exchange. Although the merchants' exchange moved to the Royal Exchange after 1769, the civic assembly and the recorder's court continued to be held in the Tholsel building until its demolition in 1809 and it was also a place of civic entertainment on occasions such as the king's birthday.

◄ Fig. 32: Tholsel, 1681, by Thomas Dineley (NLI, MS 392).
▲ Fig. 33: Tholsel, from Charles Brooking, *A map of the city and suburbs of Dublin* (1728).
▼ Fig. 34: Tholsel, 1793, from James Malton, *A picturesque and descriptive view of the city of Dublin …* (1792–9).

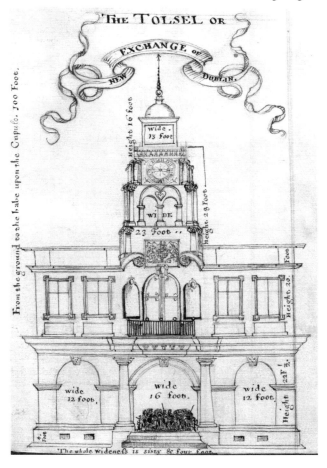

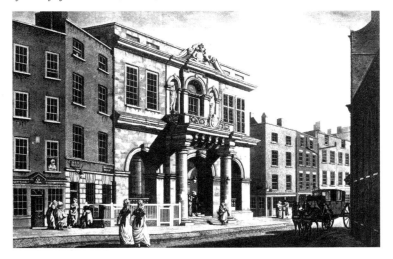

29. THOLSEL

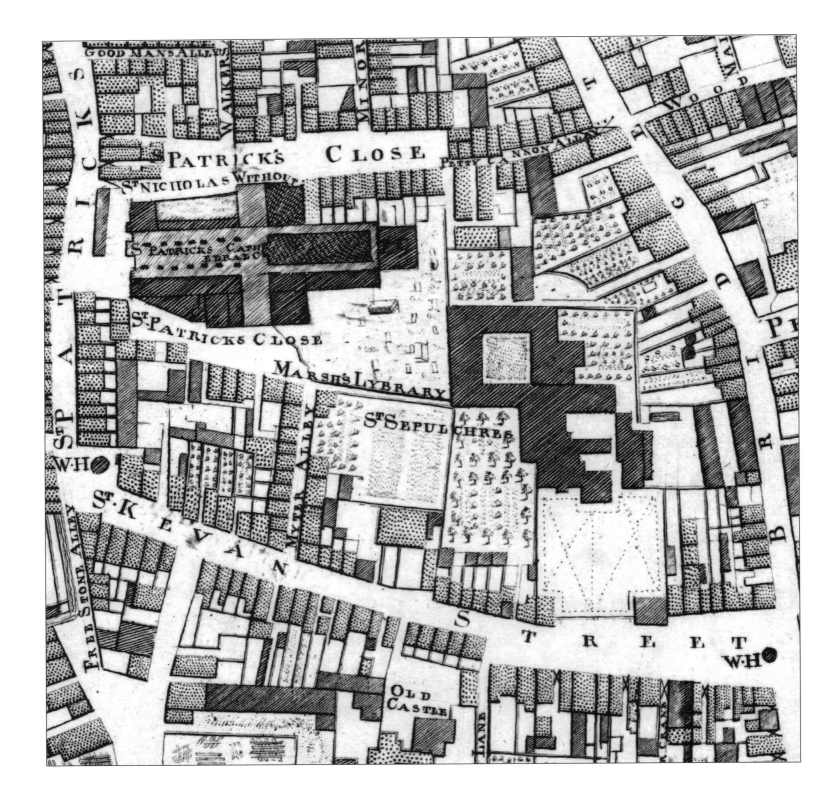

Unlike its counterpart cathedral, Christ Church, which was compressed into a cramped city block, St Patrick's (Fig. 35, below), as it appears on Rocque's map, retained its relatively spacious surroundings by means of its cathedral close. Houses were laid out on all four sides of the area labelled as 'St Patrick's Close', while a terrace of ten dwellings pressed hard against the eastern end of the church. As well as the nave and choir of the church, Rocque correctly locates the parish church of St Nicholas Without in the north transept of the cathedral and the French church (FC) at the eastern end of the building. There is no designation on the map of the southern parts of the building such as the consistory court and the chapter house, although these are demarcated by differently shaded areas. Also indicated in the vicinity of the cathedral are Marsh's Library, which is linked to the close by a narrow passage, named on Kendrick's 1754 map of the liberty of St Patrick's Cathedral as Library Alley, and St Sepulchres, the palace of the archbishop of Dublin and focus of his liberty (Fig. 36, right).

Rocque's depiction of St Patrick's is very different from his image of Christ Church Cathedral (see **28**) to the north. Christ Church was represented by a very loose, flawed plan, while this second cathedral is much more carefully delineated. An effort is made to demarcate the different zones by means of lighter diagonal shading, contrasted with a much heavier diagonal for what appear to be adjunct buildings on the north and south of the side aisles of the nave of the cathedral. Comparisons with other contemporary plans, such as Kendrick's, suggest that Rocque had a more intimate knowledge of both the footprint of the building and its interior than he had of Christ Church. The choir stalls, not labelled but suggested by the diagonally hatched zone on the east end, are in their correct position and Rocque has also correctly counted the aisle piers in the nave. All of this suggests that Rocque had direct access to this cathedral. This is likely to have been because of the location of the French chapel in the position of the Lady Chapel at the east end of St Patrick's, where Huguenots who accepted most of the strictures of the established church were allowed to worship in their own language.

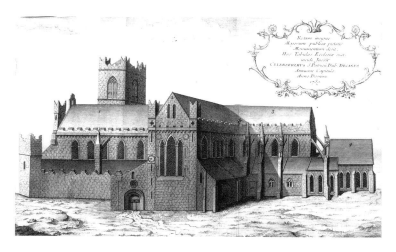

◀ Fig. 35: St Patrick's Cathedral, *c.* 1739, by Jonas Blamyres.
▲ Fig. 36: Part of map of the liberty of St Patrick's Cathedral, 1754, by Roger Kendrick (Marsh's Library).

 30. ST PATRICK'S CATHEDRAL

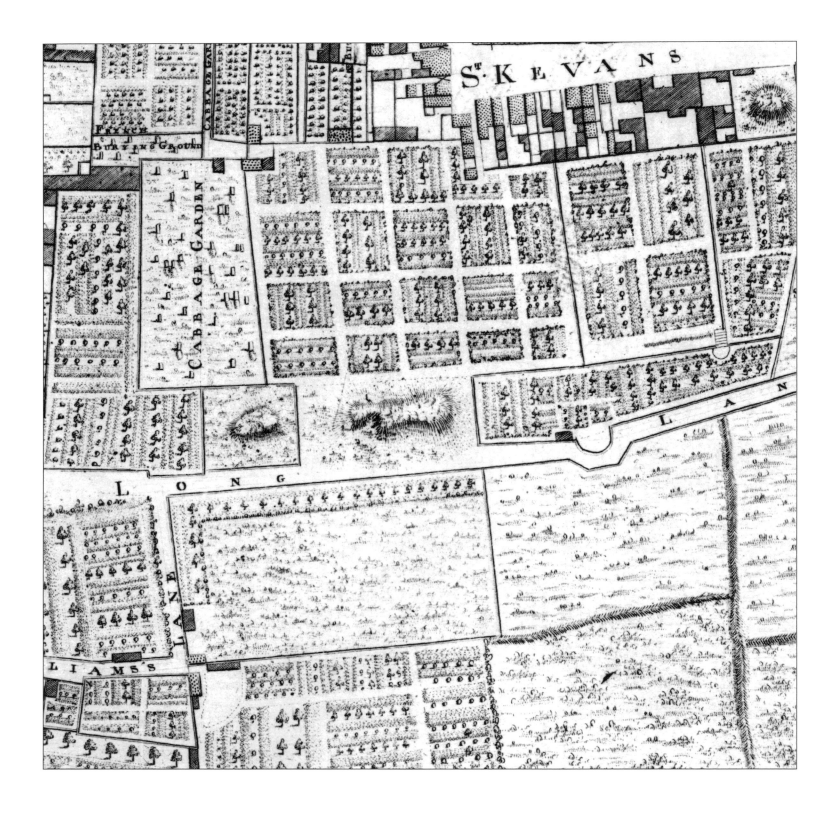

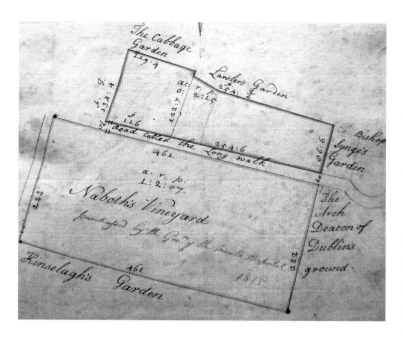

Fig. 37: Map of Naboth's Vineyard, 1749, by Roger Kendrick (Marsh's Library).

On the south side of Long Lane in the archbishop of Dublin's liberty of St Sepulchre, Rocque depicted an unnamed rectangular garden that was lined on the north side by a row of trees. This can be identified by comparison to an estate plan made by Roger Kendrick in 1749 as the $1^1/_4$-acre garden first leased by Jonathan Swift, dean of St Patrick's, in 1721 and named by him Naboth's Vineyard (Fig. 37, left). Naboth was an Old Testament character who had his vineyard taken from him against his will by his powerful neighbour King Ahab, and Swift openly adverted to his own avaricious securing of the property by naming it as he did. In a letter to Letitia Pilkington he said: '[it is] a garden that I cheated one of my neighbours out of'. We know from Swift's correspondence with Alexander Pope, one of the pioneers in the early eighteenth century of a more naturalistic style of landscape design, that he built a south-facing wall lined with bricks for greater heat for the cultivation of fruit. Along that wall he planted peach, nectarine, pear and apple trees. These were separated from the rest of the garden by a hedge, the other side of which was laid out to pasture for his horses. Swift's description of the garden is matched in detail by Rocque's image of it: the line of trees is shown along the south-facing (north) wall and the pasture for his horses is separated from them by a ditch or hedge. A later note on Kendrick's lease map states that the garden was sold to the governors of the Meath Hospital in 1815, and that is where the buildings of the Victorian hospital remain to this day.

To the north of Swift's garden and Long Lane can be seen the oddly named Cabbage Garden burial ground, and directly north of this again is the smaller French burial ground where members of the Dublin Huguenot community who worshipped in St Patrick's Cathedral Lady Chapel were buried. The Cabbage Garden reputedly was named as such because Cromwellian soldiers used it for growing cabbages — a crop they claimed to have introduced to Ireland — before it became an extension to the overly cramped graveyard adjacent to the cathedral. Kendrick's map records the location of Archbishop Synge's garden just north of Swift's and Rocque shows an orchestra-shaped projection on its southern wall, altering the shape of Long Lane, although there are no longer signs of this on the ground today.

 31. NABOTH'S VINEYARD

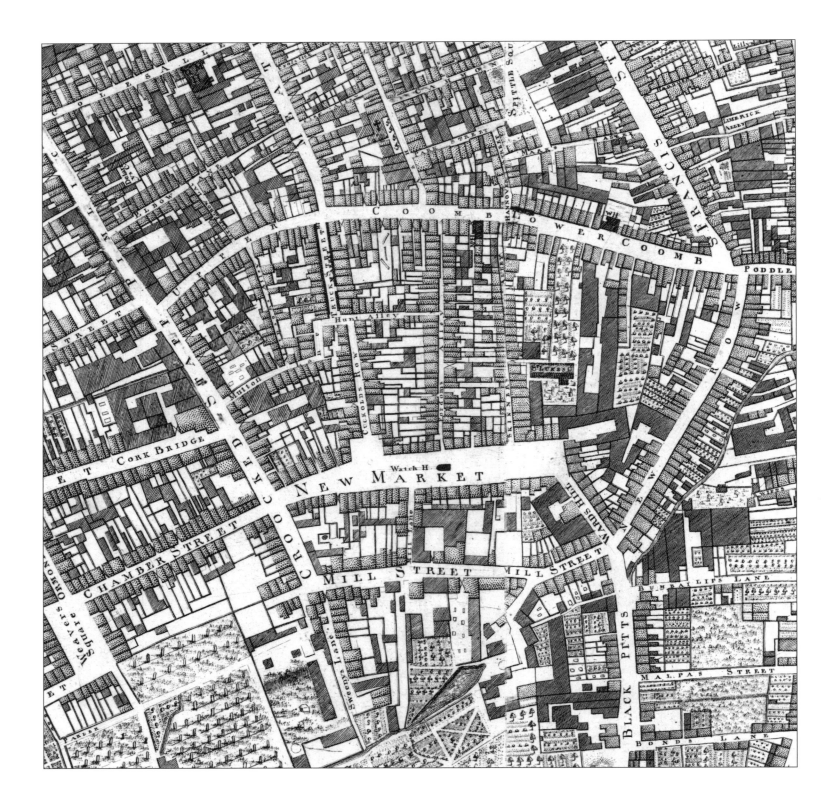

The church of St Luke is shown on Rocque's map at the end of an avenue of trees accessed from the Lower Coombe, an ancient river valley that ran east–west towards St Patrick's Cathedral. A number of upstanding graves-labs of a burial ground, which still survives beside the now ruined church building, are also shown. Construction of the church in 1715–16 was overseen by surveyor-general, Sir Thomas Burgh but most likely followed the primitive designs of his head carpenter, Isaac Wills. A simple rubble masonry single-chamber hall of the type pioneered in the previous century by the English architect, Christopher Wren, the church was originally entered on the north side through a fine classical doorway carved in granite by John Whinnery (Fig. 38, right).

St Luke's was at the centre of an industrial area whose origins are traceable to the late twelfth century. The triangular zone formed by the Upper and Lower Coombe on the north, Crooked Staff (Ardee Street) and Sweenedy's Lane (Terrace) on the west, and New Row on the east was part of the estate of Donore granted to St Thomas's Abbey by King Henry II in 1177. The area was dominated by the River Poddle, and portions of this river on the west side of Crooked Staff and Pimlico, at the rear of the houses on New Row and south of Mill Street, are shown as still above ground by Rocque. Rerouted by the Augustinian monks of St Thomas's Abbey, this tributary to the Liffey was directed through the abbey lands providing water for irrigation and to power the Double Mills (or Abbey Mills) at the rear of Mill Street, where part of the stream is still visible today. Following the dissolution of the monasteries, the estate was granted to William Brabazon, the ancestor of the earls of Meath. The ancient liberty of St Thomas, which gave juris-

Fig. 38: St Luke's Church, *c.* 1820 (National Gallery of Ireland).

dictional independence to these lands, was retained by the Meath estate. In the seventeenth century the area was settled by Huguenot refugees and Quakers who brought with them new craft skills and business and distribution networks. The earl secured a royal licence in 1674 to create a market and Newmarket — the large open space south of St Luke's — was established. This agricultural market provided outlets and raw materials for the many tanners, skinners, butchers, seed merchants, traders in hides and brewers who settled in the area. Many of the houses in which they lived and worked — the characteristic late seventeenth-century 'Dutch Billys' — survived into the second half of the last century, but sadly all have been cleared away.

32. ST LUKE'S AREA — INDUSTRIAL QUARTER

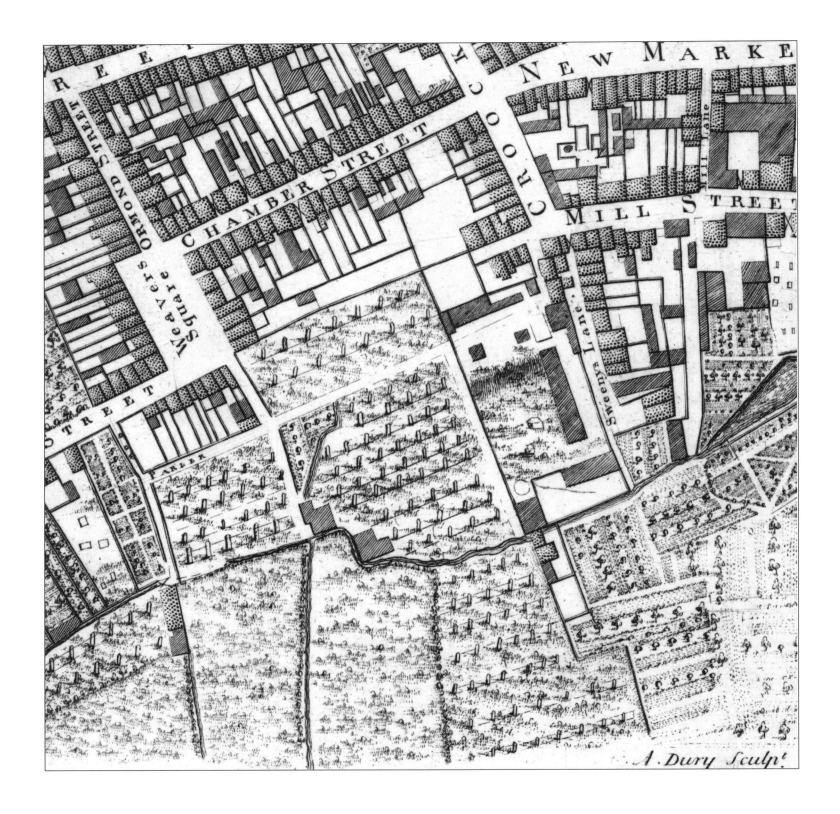

At the southern edge of the city on Rocque's *Exact survey* are depicted a number of fields with regularly arranged posts in parallel rows. These, though unnamed on the map, are tenterfields containing the wooden frames used by weavers to dry out and clean their woven cloths by stretching them between posts in the open air. The cloths were fixed to the frames by iron tenterhooks. It was on this otherwise sparsely developed part of the map that Rocque's engraver, Andrew Dury, signed his name. The location of these fields in the earl of Meath's liberties attests to the importance of the cloth working community in the area. Giving out onto the fields is Weavers' Square, while a short distance to the north on the Lower Coombe was the headquarters of the cloth working trade, Weavers' Hall (WH) (see **32**), constructed in 1745. A very large commercial space had also come into existence to serve the trade in wool and cloth in the form of Newmarket in the heart of the liberties (see **33**).

In his developing of a suburban estate, the earl of Meath had been very successful in attracting a substantial industrial population to his liberty. Among these newcomers were religious refugees from the Continent, including Huguenots and other Protestant refugees who brought with them their skills in textile weaving, especially in silk. Settling on the earl of Meath's estate, together with indigenous weavers, they quickly established it as the foremost industrial quarter in the city. Among the advantages enjoyed by the industry in the locality were the branches of the River Poddle (one of which can be seen running though the fields, perhaps the tenter watercourse), supplying water for the fulling and cleaning of the cloth. Another influence of the northern European émigrés was upon the architecture of the district where the streets and squares were noted for the brick-built houses with stepped, curvilinear gables, which were nicknamed 'Dutch Billys' (Fig. 39, right).

Unfortunately the drying of cloth as described was extremely weather-dependent and resulted in long periods of unemployment among the cloth workers. In 1813–15, as a result of memorials addressed by the weavers to the earl of Meath and through him to the Dublin Society, the Dublin philanthropist Thomas Pleasants paid for the purchase of a site on Cork Street and for the construction of the enormous 15-bay Stove Tenter House where finished cloth could be stretched and dried indoors. The building has survived and was recently converted as Sophia Housing residences for the homeless.

Fig. 39: Example of a 'Dutch Billy' house in Mill Street, from *Irish Builder*, 15 Jan., 1880.

33. TENTERFIELDS

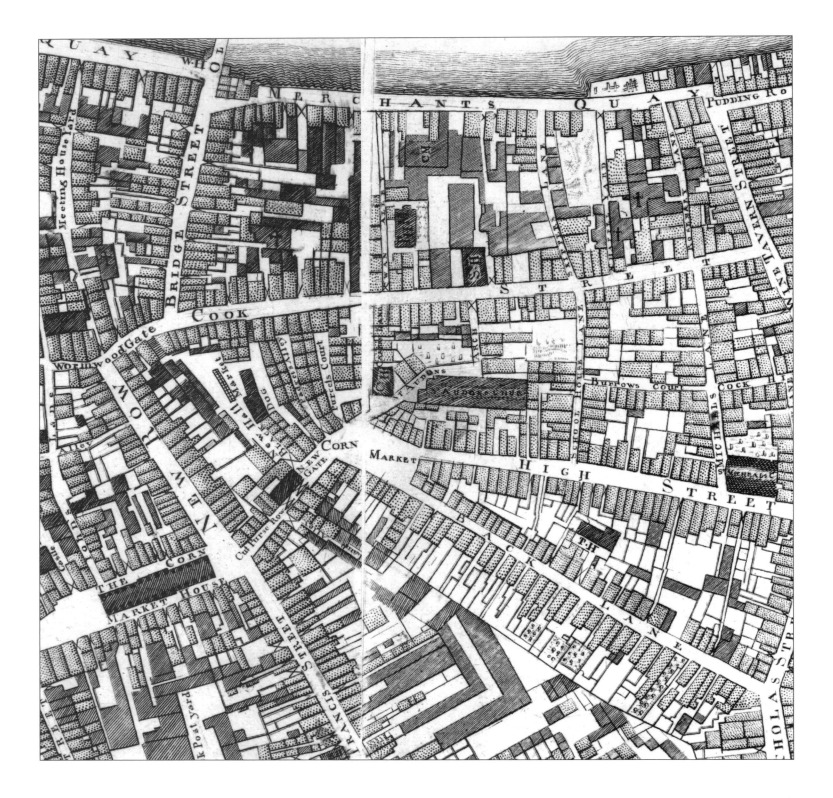

In the north-western district of the former intramural enclave of Dublin are shown four Roman Catholic chapels, with another lying slightly to the west of the old walled area. They are indicated by a cross symbol and all were located between the line of Cook Street/Wormwood Gate/Mullina Hack and the river. Going westwards from the eastern end of Cook Street, the chapels in question are as follows: two between Rosemary Lane and Chappel Yard (Fig. 40a) both run by secular clergy; one east of Bridge Street run by the Franciscans; a Carmelite chapel west of Bridge Street (Fig. 40b); and a convent chapel of Augustinian nuns ('Nunry') north of Mullinahack (Fig. 40c). In addition, there was a Dominican chapel east of Bridge Street in existence about 1750, but not shown on Rocque. The persistence of buildings for worship by members of the Catholic community in the medieval heartland during an era of official proscription is worthy of examination.

When the state-established Church of Ireland took over the medieval parish churches of Dublin, including the church buildings, after 1560, the majority of the Catholic community switched their places of worship to mass houses, usually private residences or halls. In the north-western urban core area, at least six were established by the early decades of the seventeenth century, including at least two houses of religious orders. Although subject to periodic episodes of repression by the state authorities, particularly at times of political turbulence, these congregations retained at least a vestigial presence in the neighbourhood down to the late seventeenth century. When a revival of the Catholic church took place in early eighteenth-century Dublin in an atmosphere of uneasy toleration, new chapels and nunneries were established in the expanding districts north of the river, but some of the older locations underwent restoration or refoundation, adapting to the structural changes.

Thus, in 1756, the location of chapels was correlated to the older parochial boundaries, which had been inherited by the Anglican church and adapted to population shifts, or to former religious foundations that had been dissolved. For example, the parochial chapel north of Cook Street and east of the significantly-named Chappel Yard, was the centre for a Catholic equivalent of the old-established St Audoen's parish, while the immediate proximity of another, west of Rosemary Lane, is explained by the need to serve the combined parishes of St Michael, St John, St Nicholas Within and St Werburgh. To complement these parochial chapels, there were three places of worship for Catholics in the district that were run by religious congregations. The Franciscan chapel, which became known as Adam and Eve's, served the Cook Street/Bridge Street area and later became the focus of the parish of the Immaculate Conception, Merchant's Quay. At a short distance was the Dominican chapel, which that order had re-established close to its former convent, and the discalced Carmelites north of Wormwood Gate. A community of Augustinian nuns had relocated to Mullina Hack shortly before Rocque's survey of 1756. Both Carmelites and Augustinians had had foundations close to the medieval walled city, at Whitefriar Street and New Gate, respectively.

The location of these centres for Roman Catholic inhabitants of the older districts of Dublin reflects the continuity of worship and of late medieval institutions and parishes. Yet, while the Anglican parish churches had frontages on thoroughfares, the Catholic chapels were approached by narrow lanes, leading to their unadorned exteriors. The irregular shapes of the Rosemary Lane and Chappel Yard chapels may suggest the gradual extension of the sites, which had previously been occupied by warehouses and stables.

Fig. 40: Details of Cook Street area chapels from the *Exact survey*.

 34. COOK STREET AREA CHAPELS

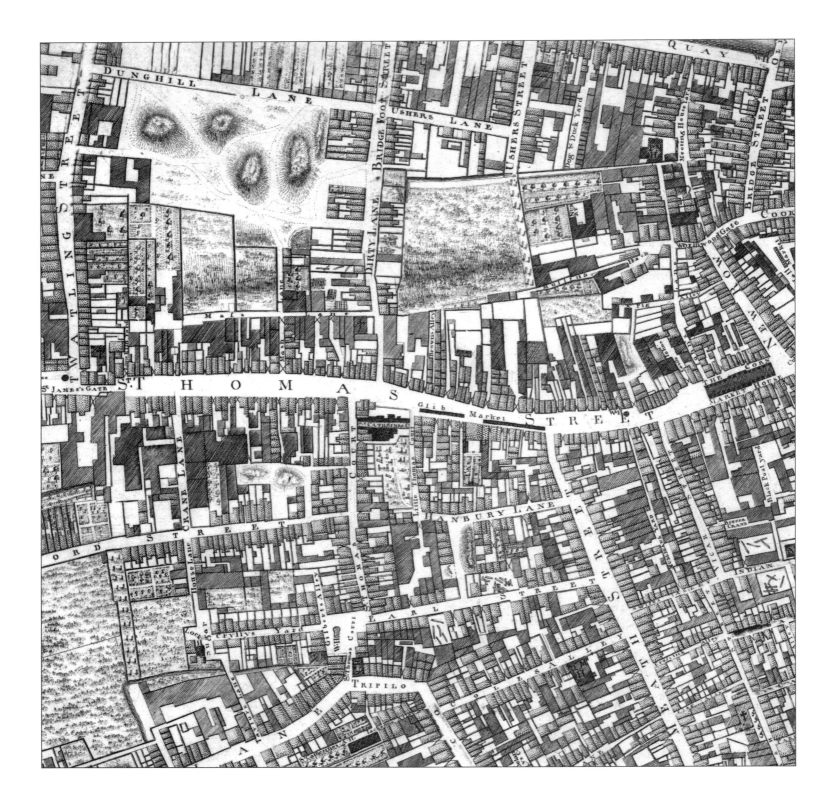

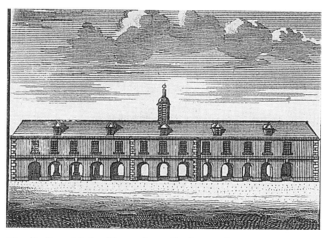

Fig. 41: Corn Market House, from Charles Brooking, *A map of the city and suburbs of Dublin* (1728).

While retaining its meandering, medieval character with over 170 frontages backed by former burgage plots, St Thomas Street, with its adjacent lanes and new intersections running from the earl of Meath's liberty, had become fairly intensively industrialised by 1756. On both north and south sides, a series of large and small commercial enterprises was built behind the houses and shops along the street front. Among the manufactories that were located in the quarter were a brewery, distilleries, malt houses, a glass house, a brass foundry, card manufactories, breeches manufactories and a lime kiln. Two markets were established in the street: the Corn Market House, which was built in 1726 to house the traditional grain trading at the western approach to the old city (Fig. 41, left), and the Glib Market, represented by Rocque as two long and narrow rectangles east of St Catherine's Church. The Glib Market, dating from the 1690s, may have specialised in trading in hides and it retained in its name the association with the Glib Water that had flowed along St Thomas Street before turning north to enter the Liffey.

The origins of the St Thomas Street suburb are to be found in the establishment of the abbey of St Thomas the Martyr in the late twelfth century. This was founded by William fitzAudelin in 1177, on behalf of Henry II, as an act of atonement for the murder of Thomas Becket, the archbishop of Canterbury. A suburb was created along the Slighe Mhór, the ancient western highway that headed in the direction of Kilmainham and intersected with the north–south highway, running along Francis Street and northwards across the river. An urban form was adopted from the beginning on either side of a very wide highway suitable for markets. The usual method of maximising the number of properties with direct access to such a market space — but with adequate space for gardens, sheds and workshops, often serviced to the rear by a back lane — were the typically elongated ranks of burgage plots common in market towns throughout Europe in the middle ages and afterwards. This street pattern has been recorded on Rocque and preserved in the present city. The Glib Market, the Corn Market, and the shape and proportions of the house plots, as shown on Rocque, and the stalls that line the street today represent a pattern of urban activity that stretches back to the twelfth century.

35. ST THOMAS STREET DISTRICT

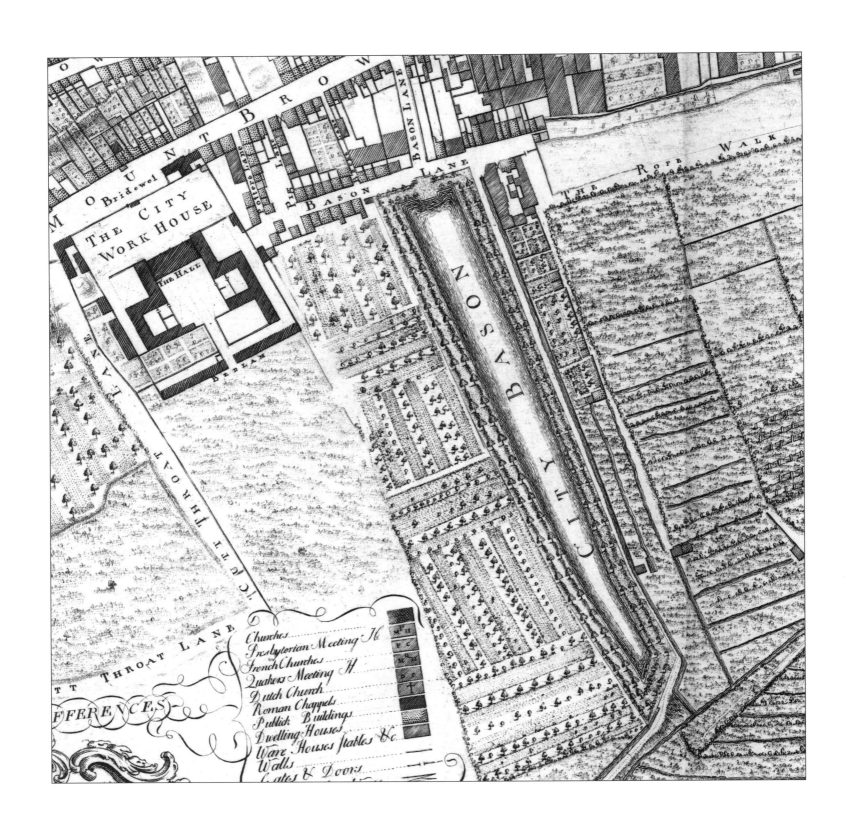

MOUNT BROW

BASON LANE

PIE O...

BASON LANE

O Bridewel

THE CITY
WORK HOUSE

THE HALL

BEDLAM

LANE

SCUTT THROAT

THROAT LANE

SCUTT THROAT LANE

FFERENCES

CITY BASON

THE ROPE WALK

Churches...........................
Presbyterian Meeting H...........
French Churches..................
Quakers Meeting H...............
Dutch Church....................
Roman Chappels..................
Publick Buildings................
Dwelling Houses..................
Ware Houses stables &c...........
Walls...........................
Gates & Doors..................

The City Bason depicted by Rocque at Mount Brown had been constructed by 1724 to replace an older cistern located at St James's Gate. The latter was proving inadequate in the early eighteenth century to deal with the demand for water supplies from a rapidly increasing population. Dublin's water supply had, since the middle ages, come from the Dodder and Poddle rivers flowing into the Liffey from the south-west, the two rivers being joined by a man-made aqueduct between Balrothery and Kimmage. From the old basin at St James's Gate the water flowed along St James's Street and St Thomas Street to supply the city. The new basin was built to manage the problem of waste water that had previously flowed out of the system: this reservoir could hold up to ninety days' supply for the city. The water to the city was piped under pressure from the north end of the basin through Bason Lane into St James's Street to connect with the mains in St Thomas Street. This was the source of supply for Dublin for much of the pre-modern period, though water was also brought in from the Liffey at Islandbridge. Dublin was, by comparison with other large cities such as London, deemed by observers to be fortunate in its abundant supplies of pure, fresh water flowing from the nearby mountains. By Rocque's time, the new Grand Canal was being constructed to connect with the basin and watercourse system.

The utilitarian aspect of the basin was deliberately softened by its being designed to provide a recreational amenity for the citizenry. In Brooking's vignette of 1728 (Fig. 42, right), the reservoir is an oblong, with the southern end narrowing into a pentagonal shape. Brooking showed it as possessing an ornate gateway with an iron gate, which led into a tree-lined promenade surrounding the whole of the basin. It became a very popular place of resort for relaxation and walking by the mid-century. The raised terracing along the edges was planted with hedges, limes and elms, and from the walkways there was a splendid vista of the Dublin mountains. Set in the south-western rural fringe of gardens, meadows and bleach greens, the hinterland of the basin was free of building, except for the City Workhouse just to the west (see **37**). It may have presented an attractive alternative to the fashionable promenades of Sackville Street, St Stephen's Green and Marlborough Bowling Green to folks of more humble social station.

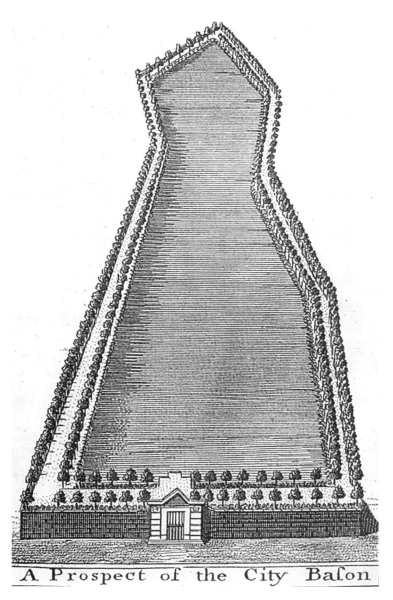

A Prospect of the City Bason

Fig. 42: City Basin, from Charles Brooking, *A map of the city and suburbs of Dublin* (1728).

36. CITY BASON

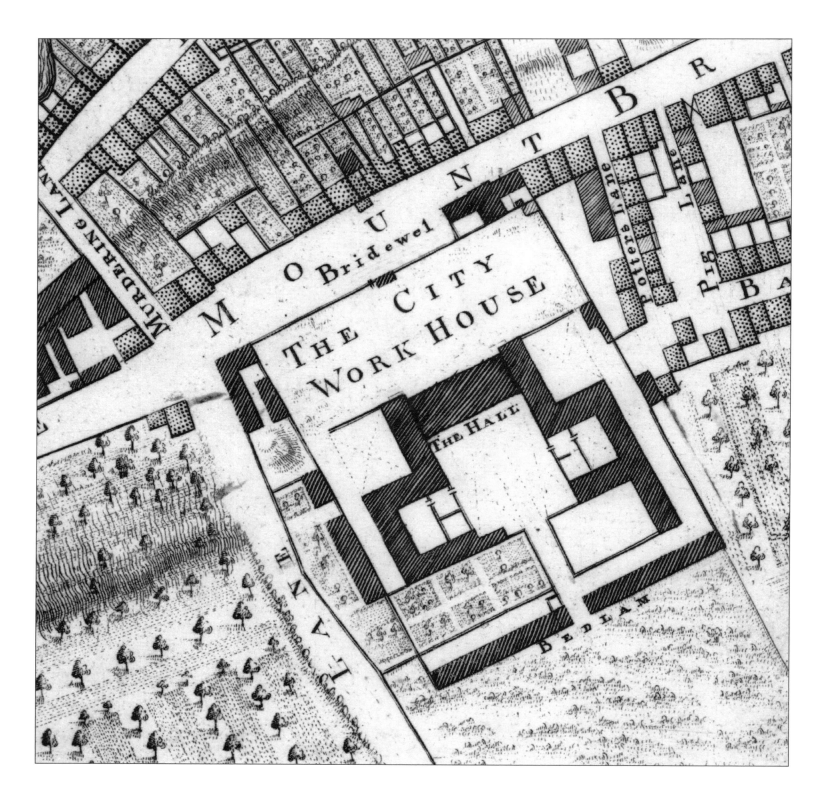

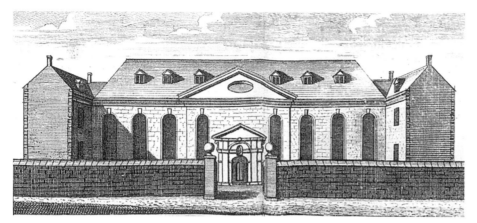

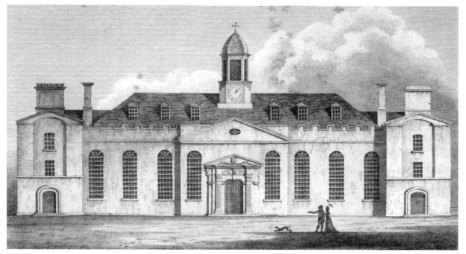

▲▲ Fig. 43: City Workhouse, from Charles Brooking, *A map of the city and suburbs of Dublin* (1728).
▲ Fig. 44: City Workhouse, from John Warburton *et al.*, *History of the city of Dublin* (1818).

in the city who were put to work in the production of cloth and other tasks. Within a few years an infirmary and bedlam, containing cells for the insane, were added. By 1730, the bridewell or house of correction in Oxmantown had been transferred to the City Workhouse site, and about the same time the function of the workhouse was extended to incorporate a hospital for foundlings. By the 1750s, thousands of abandoned children from all over Ireland had been lodged in the institution in generally deplorable conditions. Thus, simultaneously on the same campus were confined imprisoned vagrants, poor adult and child labourers, orphaned infants and the physically and mentally ill. In the latter part of the century more specialised institutions and forms of care were established under more enlightened regimes.

The workhouse was a U-shaped building entered on the north side through a grand hall where the inmates were fed (Figs 43, 44, left). Surviving drawings of the building, likely to have been designed by Thomas Burgh, show this to have been a nine-bay block with tall round-headed windows, a breakfront at the centre, and a large classical door copied from Michelangelo's Porta Pia in Rome. This auspicious entrance was, however, about all that was pleasant about this grim institution. Inmates were said to have been housed in cellars or vaults underneath the hall, and workshops were situated in a pair of ranges running southwards from the main block.

Beyond this were large open fields where some of the luckier inmates were put to work. It was also here that the thousands of foundlings who perished behind these walls were buried anonymously. Abandoned children were handed over through a gate with a turning mechanism and a bell that guaranteed the anonymity of those who left their babies behind. Numerous parliamentary reports described the alarming mortality rates and the despicable treatment of the children. The site was later incorporated into the South Dublin Union Workhouse, and eventually St James's Hospital, with the buildings in question being demolished in 1957.

On the site at Mount Brown occupied by the City Workhouse as shown on Rocque's *Exact survey* in 1756 are incorporated the bridewell and a bedlam. Although not displayed separately, the foundling hospital occupied the same premises. This erratic assemblage of buildings testifies to the ad hoc and unco-ordinated response of the city of Dublin to the problem of poverty and indigence in the early eighteenth century. The workhouse had been constructed by 1705 at the Mount Brown location to house the hundreds of poor

 37. CITY WORKHOUSE

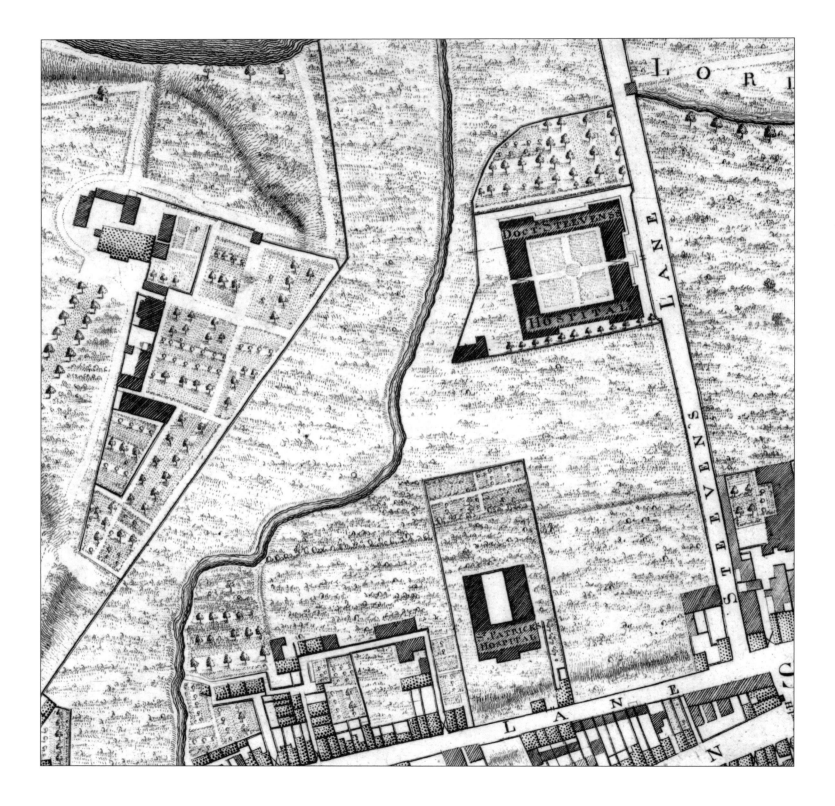

Rocque's *Exact survey* shows how close these hospitals were to one another in the south-west of the city. Indeed, taken together with the Royal Hospital (see **39**), the City Workhouse (see **37**) and the soldiers' infirmary in the same district, they form part of what Edward McParland has called 'Dublin's hospital quarter'. Like those other institutions, Dr Steevens's and St Patrick's enjoyed the benefit of the prevailing south-westerly breezes, unpolluted by the city's industrial and domestic emissions of smoke and smells. The construction of each in the decades before the mid-eighteenth century attests the vogue for private philanthropy in respect of the sick, supplemented by fund-raising conviviality, and a zeal for greater specialised medical care in purpose-built units.

Dr Richard Steevens, who died in 1710, had provided in his will for the erection of a hospital, but it was not until 1719 that building started and 1733 that it opened for its first patients. Designed by Thomas Burgh, the architect of the Royal Barracks (see **2**) and Trinity College Library (see **19**), amongst other buildings, Dr Steevens's displayed a traditional hospitaller structure in the form of a rectangle around a courtyard (Fig. 45, above), similar to that of the Royal Hospital. Three of its sides contained large wards capable of holding

Fig. 45: Dr Steevens's Hospital, from Charles Brooking, *A map of the city and suburbs of Dublin* (1728).

up to ninety beds, and the fourth housed the officers, the chapel and the library donated by Edward Worth. As depicted by Rocque, the hospital occupied a large green-field site that was undeveloped to the north as the ground descended towards the Liffey.

A portion of that site to the south of the hospital was assigned to the building of St Patrick's Hospital (Fig. 46, below) from 1749. The benefactor in this case was Jonathan Swift who bequeathed funds for a charity to care for 'lunatics', or those suffering from mental disability. Designed by George Semple, the hospital was built between 1749 and 1757 when it received its first patients. In all, fifty-seven inmates could be accommodated in rooms opening onto a U-shaped gallery, with cells in the basement for violent patients. As in the case of Dr Steevens's, which was influenced by the design of St Thomas's Hospital in London, there was a model for St Patrick's in the form of the Bethlehem Hospital (or 'Bedlam'). A more humane regime than that obtaining in earlier institutions such as the City Workhouse was envisaged for the sick in St Patrick's. Although surveyed about a year before its official opening, the hospital appears on Rocque's map in its completed form.

Fig. 46: St Patrick's Hospital, from *Dublin Magazine*, 1762, p. 303.

38. DR STEEVENS'S AND
ST PATRICK'S HOSPITALS

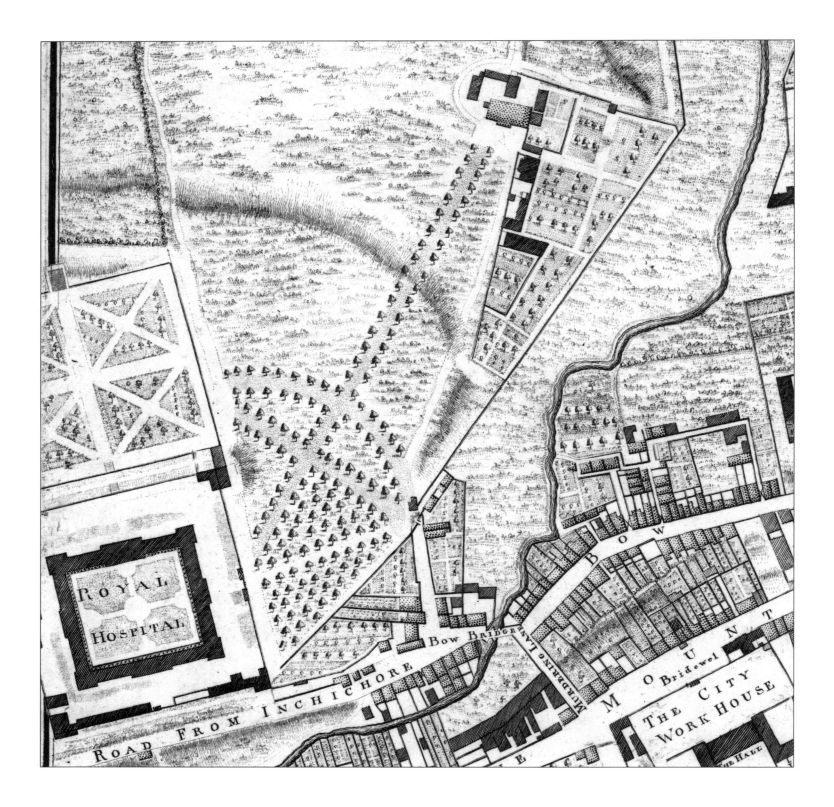

ROYAL
HOSPITAL

ROAD FROM INCHICHORE

BOW BRIDGE

MURDRING LANE

BOW

MOUNT

O Bridewel

THE CITY
WORK HOUSE

THE HALL

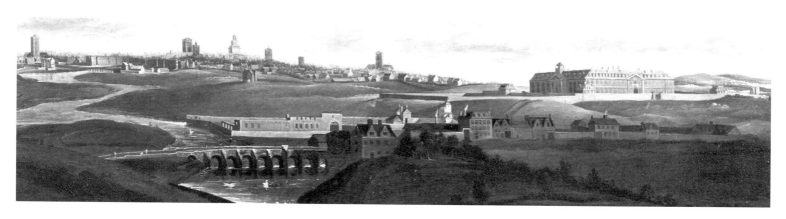

The Royal Hospital at Kilmainham is barely contained within the south-western section of Rocque's *Exact survey*. The marginal position of the hospital is significant in that the institution for superannuated soldiers was designed to remove them as potential malcontents from the city's streets and also to let them benefit by the healthful, unpolluted westerly winds (Fig. 47, above).

After a number of attempts to address the problem of sick and veteran troops during the seventeenth century, a solution was finally found with the proposal to build a large hospital, along the lines of the recently constructed Les Invalides in Paris, on a site in Phoenix Park south of the Liffey close to the old site of the Knights Hospitaller at Kilmainham. The project was largely funded by a levy on serving soldiers' pay and was under the special patronage of the duke of Ormonde. From the plan of William Robinson, the surveyor-general, the buildings took shape between 1680 and 1684 when the first residents moved in, the chapel being completed three years later.

Designed in the collegiate mode, the rectangular structure, ranged around a serene courtyard, contained the soldiers' quarters on three sides, the fourth, northerly range comprising the chapel, dining-hall and master's lodge. The hospital has the distinction of being the first classical public building in Ireland with harmonious architectural features and splendid carvings in the chapel particularly.

When completed, the hospital contained quarters for the comfortable accommodation of 400 men but, when pressed in times of military emergency such as the early 1690s, it could take in over a thousand. In the early eighteenth century, an infirmary and bedlam were built on the north-eastern corner of its grounds. Well before Rocque's time, the hospital had taken its place as a symbol of royal munificence and also civic pride. It featured prominently in all landscape views of the western approach to Dublin and its magnificence was captured in John Dunton's description of it as looking like a palace.

Rocque shows the hospital within an extended man-made landscape that falls steeply in the direction of the river to the north. This decline is indicated in plan form by means of the steps from the walled enclosure of the hospital through the series of formal master's gardens and by the two large curving strips of *hachure* lines used by map-makers at this time to suggest changes of relief. One of these cuts across the principal avenue of the *patte d'oie*, the goosefoot-shaped arrangement of paths through trees that emulated Le Notre's designs for Versailles. This change in level is confirmed by Joseph Tudor's contemporaneous reverse view from the north side of the Liffey (Fig. 48, middle).

▲▲ Fig. 47: View of Dublin and Royal Hospital, *c.* 1699, by Thomas Bate (Private collection, on loan to No. 1 Royal Crescent, Bath Preservation Trust).
▲ Fig. 48: Royal Hospital, 1753, by Joseph Tudor.

 39. THE ROYAL HOSPITAL

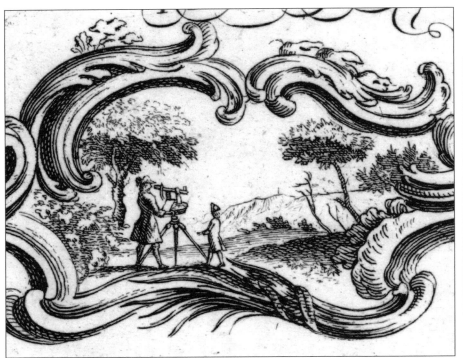

Churches
Presbyterian Meeting H.
French Churches
Quakers Meeting H.
Dutch Church
Roman Chappels
Publick Buildings
Dwelling Houses
Ware Houses stables &c.
Walls
Gates & Doors
Arches or Gate Ways

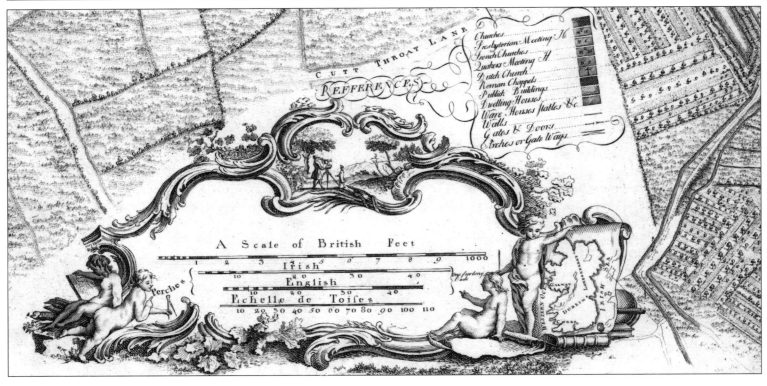

CUTT THROAT LANE

REFFERENCES

Churches
Presbyterian Meeting H.
French Churches
Quakers Meeting H.
Dutch Church
Roman Chappels
Publick Buildings
Dwelling Houses
Ware Houses stables &c.
Walls
Gates & Doors
Arches or Gate Ways

A Scale of British Feet

1 2 3 4 5 6 7 8 9 1000

Irish
10 20 30 40

English
10 20 30 40

Echelle de Toises
10 20 30 40 50 60 70 80 90 100 110

Perches

The lower cartouche, in the left-hand corner of the fourth sheet of the *Exact survey*, is also situated in an area of undeveloped agricultural land south of Kilmainham Lane (Mount Brown) and the City Workhouse (see **37**) and south-west of the City Bason (see **36**). This cartouche encloses four scale bars, the first 'A scale of British feet', the second and third representing the scales in Irish and English perches respectively, and the fourth giving an international flavour by means of an Echelle de Toises, i.e. a scale of French *toises*, a *toise* being an historic French measure equalling approximately 6 feet. On either side are pairs of *putti* in various postures — sitting, reclining, standing — either in conversation about mapping issues, deeply engrossed in atlases, or marking out with dividers. They are different in proportion to the *putti* on the upper cartouche, more adolescent than child-like, suggesting perhaps a different artist or different sources for their design. One holds up a great parchment scroll of an eccentrically outdated map image of Ireland. The figure with the dividers is certainly an emulation of François Boucher's provocative nude portrait of Louis XV's mistress, Marie-Louise O'Murphy, painted only four years earlier. The fact that the image is the reverse of the original is the result of the usual inversion caused by pressing an image on an engraved plate.

Topping this is an evocation of the surveyor (no doubt Rocque himself) at work with his assistant, set within a landscape that is also contained within a further rocaille flourish. The vegetative twirling rocaille frame can be compared to one engraved by Rocque in his and Henry Fletcher's *Sixty different sorts of ornaments invented by Gaetano Brunetti Italian painter*, published in 1736 (Fig. 49, right). The three-dimensional appearance of these twisting branches is accomplished by an experienced and assured hand, and it is highly likely that Rocque carried out this engraving himself. These are a kind of Rocquian signature to a work otherwise carried out by a wide range of assistants, including Andrew Dury whose name appears on the bottom right of the same sheet (see **33**).

Finally, above the cartouche to the right, is the 'References' legend showing the hatched and stippled symbols used by Rocque to repre-

Fig. 49: Detail of vegetative twirling rocaille frame engraved by Rocque, 1736, from Gaetano Brunetti, Henry Fletcher and John Rocque, *Sixty different sorts of ornaments invented by Gaetano Brunetti Italian painter* (London, 1736) (Yale Centre for British Art, Paul Mellon Collection).

sent the different functions of buildings on the city plan. Public buildings and Church of Ireland churches receive the heaviest stamp, warehouses and stables, dissenter churches and Roman chapels a lighter hatched symbol and dwelling houses are stippled.

40. SCALE CARTOUCHE

Andrews, J.H. 'The French school of Dublin land surveyors'. In *Irish Geography*, xlv (1964–8), pp 275–92.

Andrews, J.H. 'Two maps of Dublin and its surroundings by John Rocque'. In *An exact survey of the city and suburbs of Dublin 1756 by John Rocque: facsimile maps in 8 sheets*. Lympne Castle, Kent, 1977.

Bonar Law, Andrew and Bonar Law, Charlotte. *A contribution towards a catalogue of engravings of Dublin city and county*. 2 vols. Shankill, Dublin, 2005.

Boyd, Gary. *Dublin, 1745–1922: hospitals, spectacle and vice*. Dublin, 2006.

Brady, Joseph and Simms, Anngret (ed.). *Dublin through space and time (c. 900–1900)*. Dublin, 2001.

Burke, N.T. 'An early modern Dublin suburb: the estate of Francis Aungier, earl of Longford'. In *Irish Geography*, vi (1972), pp 365–85.

Burke, N.T. 'Dublin 1600–1800, a study in urban morphogenesis'. TCD, Ph.D. thesis, 1972.

Burke, N.T. 'A hidden church? The structure of Catholic Dublin in the mid-eighteenth century'. In *Archivium Hibernicum*, xxxii (1974), pp 81–92.

Casey, Christine. *The buildings of Dublin: the city within the Grand and Royal Canals and the Circular Road with the Phoenix Park*. New Haven and London, 2005.

Clare, Liam. 'The Putland family of Dublin and Bray'. In *DHR*, liv (2001), pp 183–209.

Cosgrave, E. MacDowel. 'On two maps, dated 1751 and 1753, of the Essex Bridge district, Dublin'. In *RSAI Jn.*, viii (1918), pp 140–49.

Craig, Maurice. *Dublin, 1660–1800*. 2nd ed. Dublin, 1980.

Crawford, John and Gillespie, Raymond (eds). *St Patrick's cathedral, Dublin: a history*. Dublin, 2009.

Curran, C.P. 'The architecture of the Bank of Ireland: part I, the Parliament House 1728–1800'. In *Quarterly bulletin of the Irish Georgian Society*, xx, nos 1, 2 (1977), pp 3–36.

De Courcy, J.W. *The Liffey in Dublin*. Dublin, 1996.

Doran, Gráinne. 'Smithfield market – past and present'. In *DHR*, l (1997), pp 105–118.

Dudley, Rowena. 'St Stephen's Green: the early years, 1664–1730'. In *DHR*, liii (2000), pp 157–79.

Fagan, Patrick. *The second city: portrait of Dublin 1700–1760*. Dublin, 1986.

Ferguson, Kenneth. 'Rocque's map and the history of nonconformity in Dublin: a search for meeting houses'. In *DHR*, lviii (2005), pp 129–65.

Ferguson, Paul (ed.). *The A to Z of Georgian Dublin*. Lympne Castle, Kent, 1998.

Frazer, Bill. 'Cracking Rocque?'. In *Archaeology Ireland*, xviii, no. 2 (2004), pp 10–14.

Gilbert, J.T. *A history of the city of Dublin*. 3 vols. Dublin, 1854–9; reprinted 1978.

Goslin, Bernadette. 'St Andrew's church'. In *Irish Arts Review*, vii (1990–91), pp 81–84.

Gough, Michael. 'The Dublin Wide Streets Commissioners (1758–1851): an early modern planning authority'. In *Pleanáil: the Journal of the Irish Planning Institute*, xi (1992–3), pp 126–55.

Halwas, Robin. *John Rocque's survey of the Kildare estates: manor of Kilkea, 1760: a rediscovered atlas ornamented by Hugh Douglas Hamilton*. London, n.d. [2005].

Harris, Walter. *The history and antiquities of the city of Dublin*. Dublin, 1766.

Hodge, Anne. 'The practical and the decorative: the Kildare estate maps of John Rocque'. In *Irish Arts Review*, xvii (2001), pp 133–40.

Horner, Arnold. 'Cartouches and vignettes on the Kildare estate maps of John Rocque'. In *Quarterly Bulletin of the Irish Georgian Society*, xiv (1971), pp 57–76.

Howgego, James. 'The 1746 Rocque maps of London'. In *An exact survey of the city's of London, Westminster. and the country near ten miles round begun 1741 & ended in 1745 by John Rocque Land Surveyor and Engrau'd by Richard Parr*. Ed. Harry Margary. Lympne Castle, Kent, 1971.

Hyde, Ralph. 'Portraying London mid-century: John Rocque and the Brothers Buck'. In *London 1753*. Ed. Sheila O'Connell. London, 2003, pp 28–38.

Hyde, Ralph. 'The making of John Rocque's map'. In *The A to Z of Georgian London. Facsimile of John Rocque's 1746 map of London*. Lympne Castle, Kent, 1982, pp v–viii.

Kennedy, Máire. 'Politics, coffee and news: the Dublin book trade in the eighteenth century'. In *DHR*, lviii (2005), pp 76–85.

Laffan, William (ed.). *The cries of Dublin &c: drawn from the life by Hugh Douglas Hamilton, 1760*. Dublin, 2003.

 SELECT BIBLIOGRAPHY

Laxton, Paul. 'Rocque, John (1704?–1762)'. In *Dictionary of National Biography, missing persons*. Ed. C.S. Nicholls. Oxford, 1993, pp 563–64.

Lennon, Colm. *Dublin, part II, 1610 to 1756* (Irish Historic Towns Atlas, no. 19). Dublin, 2008.

Little, G.A. 'The Thingmote'. In *DHR*, xiii (1953), pp 66–71.

Loeber, Rolf. *A biographical dictionary of architects in Ireland 1600–1720*. London, 1981.

Maguire, J.B. 'Seventeenth-century plans of Dublin castle'. In *RSAI Jn.*, civ (1984), pp 5–14.

McCarthy, Patricia. *"A favourite study": building the King's Inn*. Dublin, 2006.

McCready, C.T. *Dublin's street names*. Dublin, 1892.

McCullough, Niall (ed.). *A vision of the city: Dublin and the Wide Streets Commissioners*. Dublin, 1991.

McCullough, Niall. *Dublin, an urban history: the plan of the city*. Dublin, 2007.

McParland, Edward. 'Edward Lovett Pearce and the parliament house in Dublin'. In *The Burlington Magazine*, cxxxi, no. 1031 (1989), pp 91–100.

McParland, Edward. 'Strategy in the planning of Dublin, 1750–1800'. In Paul Butel and L.M. Cullen (eds), *Cities and merchants: French and Irish perspectives on urban development, 1500–1900*. Dublin, 1986, pp 97–107.

McParland, Edward. 'The Wide Streets Commissioners, their importance for Dublin architecture in the late–eighteenth and early nineteenth centuries'. In *Quarterly Bulletin of the Irish Georgian Society*, xv (1972), pp 1–32.

McParland, Edward. *Public architecture in Ireland, 1680–1760*. New Haven and London, 2001.

Milne, Kenneth (ed.). *Christ Church Cathedral Dublin*. Dublin, 2000.

Montague, John. 'A shopping arcade in eighteenth-century Dublin: John Rocque and the Essex Street "piazzas"'. In *Irish Architectural and Decorative Studies,* x (2007), pp 224–45.

Montague, John. 'John Rocque and the making of the 1756 *Exact survey of Dublin*'. Trinity College, Dublin, Ph.D. thesis, 2009.

Montague, John. 'St Luke's in the Coombe'. In Shaffrey Associates Architects (eds), *St Luke's Conservation Plan*. Dublin, 2003, pp 24–37.

Pearson, Peter. *The heart of Dublin: resurgence of an historic city.* Dublin, 2000.

Pedley, Mary. *The commerce of cartography: making and marketing maps in eighteenth-century France and England.* London, 2005.

Phillips, Hugh. 'John Rocque's career'. In *London Topographical Record*, xx (1952), pp 9–25.

Ross, Ian Campbell (ed.). *Public virtue, public love: the early years of the Dublin lying-in hospital: The Rotunda.* Dublin, 1986.

Ryan, Patrick. 'The water supply of early modern Dublin: archaeology, history, cartography'. University College Dublin, Ph.D. thesis, 2007.

Sheridan-Quantz, Edel. 'The multi–centred metropolis: the social topography of eighteenth–century Dublin'. In Peter Clark and Raymond Gillespie (eds), *Two capitals: London & Dublin 1540–1840.* Oxford, 2001, pp 265–95.

Simpson, Linzi. 'John Rocque's map of Dublin (1756): a modern source for medieval property-boundaries'. In Sean Duffy (ed.), *Medieval Dublin VII*. Dublin, 2006, pp 113–51.

Smyrl, S.C. *Dictionary of Dublin dissent: Dublin's protestant dissenting meeting houses 1660–1920.* Dublin, 2009.

Twomey, Brendan. *Smithfield and the parish of St Paul, Dublin, 1698–1750.* Dublin, 2005.

Usher, Robin. 'Reading architecture: St Andrew's Church, Dublin, 1670–1990'. In *Visual Resources*, xxiv, no. 2 (2008), pp 119–32.

Varley, John. 'John Rocque. Engraver, surveyor, cartographer and map-seller'. In *Imago Mundi*, v (1948), pp 83–91.

Wheatley, Henry. 'Rocque's plan of London'. In *London Topographical Record*, ix (1914), pp 15–28.

Wodsworth, W.D. *A brief history of the ancient foundling hospital of Dublin, from the year 1702: with some account of similar institutions abroad.* Dublin, 1876.

Wright, G.N. *An historical guide to the city of Dublin, illustrated by engravings, and a plan of the city.* London, 1825.

SELECT BIBLIOGRAPHY